Reimagining
GREENVILLE

· ·

BUILDING THE BEST
DOWNTOWN IN AMERICA

*Welcome to
Greenville ~
JCw*

JOHN BOYANOSKI *with* KNOX WHITE

THE
History
PRESS

Published by The History Press
Charleston, SC 29403
www.historypress.net

Cover images courtesy of Todd Williams at Magnolia Studios, the Greenville Drive and John Boyanoski.

First published 2013
Second printing 2014

Manufactured in the United States

ISBN 978.1.60949.974.7

Library of Congress Cataloging-in-Publication Data

Boyanoski, John.
Reimagining Greenville : building the best downtown in America / John Boyanoski with Knox White.
pages cm
Includes bibliographical references and index.
ISBN 978-1-60949-974-7
1. Greenville (S.C.)--History. 2. Central business districts--South Carolina--Greenville--History. 3. City planning--South Carolina--Greenville--History. 4. Economic development--South Carolina--Greenville--History. 5. Social change--South Carolina--Greenville--History. 6. White, Knox. 7. Politicians--South Carolina--Greenville--Biography. 8. Greenville (S.C.)--Politics and government. 9. Greenville (S.C.)--Economic conditions. 10. Greenville (S.C.)--Social conditions. I. White, Knox. II. Title.
F279.G79B68 2013
975.7'27--dc23
2013020721

For Hannah and Tammy

For Marsha, Marian and Knox Jr.

Contents

Acknowledgements

I would like to thank a lot of people. First would be Tammy Johnson, who had to watch me sweat out this book for numerous months. She means more to this project than she would ever know. I want to thank all of my friends who had to listen to me prattle on about the things I found out about downtown Greenville while researching this book. I can't imagine how boring I must have been, but I owe them a debt of gratitude. Their reactions and questions helped shape this book. Good reactions led to stories that made the book; bad reactions did not. Also, a big thank-you to Chad Rhoad, our editor from The History Press. I am sure there were days he wanted to strangle me via e-mail. My daughter, Hannah, is also a big part of this book. She has never known a downtown that wasn't cool and can tell anybody who will listen about the Rainbow Reedy, why there are bells in the trees and where her favorite toy store is located.

John Bozanoski

Introduction

I wish the following were not a true story. The first time I saw Main Street with my own eyes was in 1999, when I came to town for a Black Sabbath concert at the Bi-Lo Center. I was working for the *Spartanburg Herald-Journal* at the time and of course knew that Greenville had what was considered a "cool" Main Street, but I didn't actually see it until I came on a Sunday to see Ozzy, Toni, Geezer and Bill on one of their reunion tours.

At the time, only a few restaurants were open on a Sunday evening. I can't remember all of the choices, but we ate at a Fuddruckers—yes, a chain restaurant on Main Street. You couldn't drink alcohol on Sunday on Main Street. There was no Falls Park yet. No downtown baseball stadium. No statues. Little artwork. The Poinsett was still boarded up. Heck, I am pretty sure a portion of Main Street was closed because of that work.

To put it succinctly, Greenville was pure awesome to me. It was like no other small-city downtown I had ever seen. There were people walking around that Sunday, and not just because of Sabbath. There were shops. There were trees. There was life. There was potential. You could almost see Greenville ready to explode into the downtown it would become.

About a year later, I moved to Greenville to work for the *Greenville News*, and I got to see it explode. Not because I had moved there but because the Poinsett Hotel opened. Poinsett Plaza opened. Court Street Square was born. Main Street was a great place to hang out on a Friday night after a long week as a newspaperman. We would watch people go to shows at the Peace Center. We could go to restaurants and bars after

dinner. Soon, we could even purchase beer on Sundays. The Saturday farmers' market started.

To me, Greenville was in full stride and perfect. It was the best it was going to be in my eyes. Thankfully, I was wrong. The city pushed ahead on tearing down the Camperdown Bridge, building that downtown stadium, reclaiming the river, getting people to live downtown, investing in the arts—everything that has made Greenville great.

That is part of the reason I joined Knox in writing this book. Knox gave me unprecedented access to his volumes of files, as well as sat through extensive interviews while putting this book together. This book is about Greenville, but it is not the entire story. These are vignettes of what has happened to downtown. Greenville didn't magically happen. It wasn't easy. It was hard. There were failures. There were political battles. There were lawsuits and infighting. I wanted to tell that story because it is important and not told enough.

But in the end, it worked. Why? Despite the failures, the overall vision was never lost. That was key. That is the second reason I wanted to write this book. Greenville is not done growing and reinventing how a downtown can and should look.

And that is a story I want to tell.

John Bozanoski

Chapter 1
The Start of Something New

The greatest thing to hit downtown Greenville in the last forty years opened with a whimper.

The Hyatt Regency opened its doors—one set onto a Main Street courtyard and the other facing the traffic-heavy College Street—with no grand celebrations or explosions. No high-end cocktail party in the main ballroom. No grand dinner where Greenville's who's who ate rotisserie duckling and Neptune's Delight Under Glass, which were staples of the hotel's Teal Garden restaurant. No drink specials at Steamer's, the on-site bar. The top-hatted doorman was there, but he had no dignitaries to show inside—people like George W. Bush and Michael Jordan were a lifetime away.

No, the big story in January 1982 was the weather—a snowstorm had moved into the Upstate of South Carolina—but it wouldn't have made much of a difference. The hotel's ownership saw no need to prove itself to the local community again. A grand display wasn't needed because it had already gotten more publicity than any hotel before or since in Greenville history. The $34 million hotel's construction had dominated downtown Greenville life for almost four years, ever since bulldozers first began plowing dirt for the project. It was constantly on the front pages of the *Greenville News* and *Greenville Piedmont*. It was the talk of the Greenville Country Club. It was the story at the old Brown Box, aka the Greenville Memorial Auditorium, just a few blocks from the hotel site. It wasn't just the main story in Greenville; it was *the* story. Its proponents were calling it the start of a new era—an era

when downtown would be the centerpiece of Greenville. It is tough to tell who believed and who didn't believe the predictions through the lens of history. The popular line is that everyone was against changing the shape of downtown in the 1970s. However, few ever really come out and admit they were part of the doom-and-gloom crowd.

One name, though, almost always is notched first when talking about who believed: Max Heller.

Fittingly, Greenville's second-term mayor had driven the first earthmover when the project was announced. It was a customary pass; he had no great plans to start working that very day. Heller's plans were much greater. A survivor of the Jewish Holocaust in the 1940s, he had arrived in Greenville with little more than the shirt on his back. He turned hard work and moxie into a lucrative textile company that allowed him to retire young and run for city council in 1968. Witty and charismatic, he was begged to run for mayor in 1973. He was so revered that he announced he would not seek a second term as mayor in 1975 unless business leaders did something about downtown's decay. It was a bluff he could make. Heller's word and respect were so strong that those leaders listened. However, Heller had help on his plan. Attorney Tommy Wyche had seen a story on a gorgeous fountain in Portland in the early 1970s and contacted the urban designer Lawrence Halprin about doing something similar in Greenville. Halprin's team came to Greenville, looked around and advised that a better idea would be to create a master plan to widen the sidewalks, decrease the driving lanes and plant trees. While their statements were nicely written, the underlying statement was that downtown was a dump. To the credit of Wyche and other leaders like Buck Mickel, they listened and found a champion for the project in Heller. Part of the reason for going with Halprin's team was because it came from an authoritative, outside voice. Greenville leaders knew something was wrong but couldn't pull together to do something. Halprin could come in and say what needed to be said. Many people swallowed a bitter pill when city council pushed through a plan to lessen Main Street from four lanes to two and widen the sidewalks at the same time. Heller convinced people that planting trees was a good idea because in twenty years Greenville's downtown would have a lush green canopy.

The trees and the sidewalks were the plantings for something greater—something not completely evident in the late 1970s. City manager John Dullea said downtown had "bottomed out" and this was needed. The few businesses still operating on Main Street at the time—the joke was that drugs and sex sold more than shirts and socks—howled in displeasure. That would kill their livelihoods. Cars were what drove customers, not sidewalks for

people who never showed up. They clung to the hope that downtown would right itself on its own. But the major business leaders believed in Heller and, more importantly, supported him.

"It started with the trees," said Bob Hughes, a Greenville native and developer whose projects have played a major role in transforming Greenville. "That and the sidewalks. Widening sidewalks meant so much. It was the start. Widening the street was not nearly as important as widening the sidewalks. But since the buildings were there, one of them had to give." Hughes cited sociological studies to explain why wide sidewalks work: "Good people don't want to be near bad people. But bad people don't want to hang out near good people. They want to be left alone. On a narrow sidewalk, the bad guy wins. You don't want to go down the narrow sidewalk. Wide sidewalk, now the good guy goes down and the bad guy feels uncomfortable, so he leaves."

And business leaders supported the hotel project, which was the centerpiece of a larger development called Greenville Commons. This project wrapped around the hotel and included a five-story office building, a convention center and a 524-space garage. This project was going to spark the revitalization, but it would not be the only thing. Heller knew that, and he was laying the groundwork for the future. Oddly, while Halprin himself never physically came to Greenville to work on the project, the Hyatt and the plans for downtown are characteristic of his style. Water fountains. Redoing entire city blocks. Projects about being impressive rather than about being done to a human skill. Plenty of trees, benches and lighting before those things got dubbed "streetscaping" by urban planners.

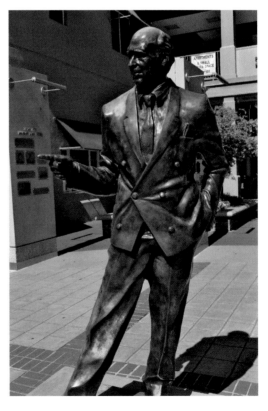

Max Heller was the mayor often credited with starting Greenville's rebirth. *Courtesy of John Boyanoski archives.*

To say that the Hyatt's construction was the end-all, be-all for the rebirth of downtown would be a gross overstatement. The construction of the twenty-five-story Daniel Building—later to be known as the Landmark Building—a decade earlier had already shown life could exist downtown. Actually, Charles Daniel, the influential head of the massive construction empire that bore his name (and no connection to the famed fiddle player), said this was his stake in the ground that Greenville's downtown was strong. "The great cities of America and those struggling for greatness have people who stand unafraid to commit themselves to the future. Greenville possesses such people in greater numbers than any city in eastern America. I urge them to answer the call for a greater today," Daniel said at the 1964 groundbreaking. And the announcement of the hotel didn't quite stem the losses either. Belk-Simpson and J.C. Penney's stores became the last major retailers to flee downtown when they headed for the newly constructed Haywood Mall—less than four miles from the foot of downtown but a lifetime away in the world of commerce—in 1980.

Even the hotel's construction was mired in bad turns and controversy. The original timeline called for an opening in 1980 and completion on a $20 million budget; both of those figures were passed like unwelcome speed bumps. Radisson was the original chain keyed into the project, but it backed out, as did the original developer. It was only through the intervention of Daniel Hartley-Leonard, the English-born and bred executive vice-president of the Hyatt chain that the hotel portion became a reality. Hartley-Leonard pushed the project through if for no other reason than that he had a local connection. His wife was a native and a cousin of Tommy Wyche, one of the city's powerbrokers and the head of the group of leaders that raised money to help fund the project.

And that financing deal—nothing like it had ever been tried before in Greenville, maybe even in all of South Carolina. It relied on a $5.5 million HUD grant and a $1.9 million U.S. Economic Development Administration grant. There was $1.3 million from Hyatt and $2.5 million from the city reserve fund. The final part was a $16 million bank loan. Public-private partnerships like this later would become the hallmark for city business deals, but in 1978, it was a considered a risk not even the hardiest gambler would take.

The die was cast.

"The Hyatt was important not just from a physical impact of being a new hotel on Main Street, but it laid the groundwork for how the city would do business in the future," said Nancy Whitworth, the city's longtime economic development director. "It was the start of the public-private partnerships. There was risk involved, of course."

Hartley-Leonard later praised the project for being forward thinking and the ultimate key to downtown's success but added a curious caveat for the "gem of the Hyatt empire": he said he would not have done it again. The hotel lost money for twelve years, as the projected growth of downtown did not fill the need for a high-end structure of glass and concrete with more than three hundred rooms. He said this in 1995 while attending a banquet in downtown Greenville (something inconceivable before the Hyatt). Greenville didn't need another hotel, he said. He sounded like the naysayers in the 1970s, but a new group of leaders didn't take heed and pushed for more than hotels. They would get more, but it wasn't easy.

Greenville's downtown has gone from blight, to the South's best-kept secret, to a Main Street that has been copied and studied by countless other cities across the United States. The success didn't happen overnight, even though many people mistakenly believe it did. Nor did it happen in a beautiful linear line—because nothing in life goes that way. The story of downtown's historic revitalization does not really have an actual starting point, but the general consensus is that it starts with the Hyatt. It was the first sign that this business-first textile town could be more than that. It could be a place where people wanted to come. A place where they wanted to raise families. A place they could tell their friends about.

But even though the Hyatt opened its doors in 1982, downtown success was a long time coming. It wasn't until the 1990s that Greenville really began to bloom. And even then, failure loomed like a kudzu vine creeping from the swamps. Every success was met with brutal battles and opposition. Unlike the opposition to the Hyatt in the late 1970s, opposition to later revitalization efforts often came publically and repeatedly. Every move was criticized and analyzed. City council meetings became jam-packed—especially when something such as tearing down the bridge spanning the Reedy River was discussed (or, more accurately at times, screamed about). The governmental battles spread beyond the tenth floor of city hall as angry residents went to the school board and county council to pounce on the opportunity to strike down items such as a downtown baseball stadium.

What happened after the Hyatt and the initial wave of good feelings from the 1970s? Not much. There were projects and announcements and developments, but no one was sticking to a plan or at least working off the same plan. Greenville's downtown crept forward in spite of itself at times.

A 1989 study asked Greenville residents to name a great downtown. Less than 5 percent chose their own. That same study, though, laid out

We have created a different model for what a downtown can look like: a business district with office towers but on the street level, a walkable village. It's all focused on people, the pedestrian. We have big anchor projects that helped, such as the Hyatt, the Peace Center, Falls Park and the baseball stadium, but in between there is a lively street of retailers, restaurants and public art. It all comes together to create an amazing downtown. If it looks easy, it is not. Many of the most successful pieces were the product of an immense amount of hard work and, in some cases, major controversy. But in the end, we had a plan and we stuck to it.

—*Knox White*

a plan that would help alter the downtown landscape by clarifying and codifying what needed to be done.

Greenville developed a plan and stuck to it through changes in council members, administrators and staff. A vision was created that called for a different kind of downtown, one that Greenville and most of the nation had never seen before. A downtown where public art was key. Where housing was needed and promoted. Where anchors and building blocks were designed to draw people in and then lead them to the rest of downtown's charms. Where retail shops were put on priority lists and underlined in red ink.

Downtown Greenville's success was not an accident, but it was not easy. Five major projects during a ten-year span helped change the face of Greenville forever. It is likely that failure on any of these projects could have doomed downtown to a lifeless rut of starts and restarts.

These were the Peace Center for the Performing Arts, which made culture a must-have for Greenville and the Upstate; reopening the Poinsett Hotel, which proved to old Greenville that it and its denizens had a place in the modern downtown; most profoundly revitalizing the area around Reedy River Falls, Greenville's birthplace; a lengthy battle with a Main Street nightclub proposal that, in the end, proved to many that Greenville wanted retail; and, finally, a downtown baseball stadium.

These projects helped spur the vast majority of what has happened: statues of iconic city leaders and sculptures on Main Street, high-rise office buildings, a walking/biking trail system, a downtown arena. The success has been noticed (nay, lauded) nationally. The city has been praised by everyone from the *Washington Post* to the *New York Times*, from

Oprah to Ben Stein, from *Garden and Gun* to *Esquire*. Syndicated columnist Neal Peirce praised Greenville for having "infrastructure with heart."

"It's lined with distinctive shops and restaurants. The traffic has been restricted to two lanes to accommodate broad sidewalks and 'take it slow' diagonal parking. The visitor is treated to distinctive, easy-to-read street signs. And something more—every block there's a sign saying how many more to Falls Park. And what's Falls Park? It's the site of the stunning 28-foot falls of the Reedy River, a piece of wilderness directly in the center of town, where the first European settler set up his trading post in 1768. And if the sound of rushing waters weren't enough, there's a breathtaking curved pedestrian suspension bridge, 355 feet long, allowing splendid views of the falls and surrounding gardens," Peirce opined in 2009 before asking if other southern cities could be like Greenville and focus on quality over "bigness."

But that's getting ahead of the story. Let's go back to the beginning.

Greenville's birth was along the Reedy River Falls, and the father, so to speak, was Richard Pearis. A native of Ireland, Pearis is often described as an Indian trader, pioneer and Tory who took the side of the British in the American Revolution. In today's language, we would call Richard Pearis an entrepreneur. He put together almost 1,200 acres of land in Virginia by age twenty-five. He opened a trading post in Tennessee. He dealt with the Cherokee and fathered a son out of wedlock. He helped retake Fort Duquesne during the French and Indian War in the 1750s. He became the official Indian agent for the Maryland Colony. And at some point in the 1760s, he came to Greenville under somewhat dubious circumstances to claim 12 acres around the Reedy River Falls. He claimed the Cherokee deeded him the land because of his half-breed son. In reality, Pearis was squatting on the land, likely illegally.

Sometime after 1770, Pearis, his family and their twelve slaves began to clear one hundred acres near the falls of the Reedy River. He built a store, a gristmill, a smokehouse, stables, a dairy, a blacksmith shop, a sawmill and slave quarters. He even had a plantation that he dubbed Great Plains, which was surrounded by orchards and grain fields. But because Pearis supported the British in the American Revolution, his property was seized. Revolutionary War veterans began to claim the Pearis land and obtain grants for other tracts in the 1790s.

In 1797, a young lawyer named Lemuel Alston purchased the soldiers' land grants, which included the Pearis property, along with scores of others, to put together 11,023 acres. Alston drew up a plan for a village he dubbed Pleasantburg. In Alston's original plan for downtown, Main Street was

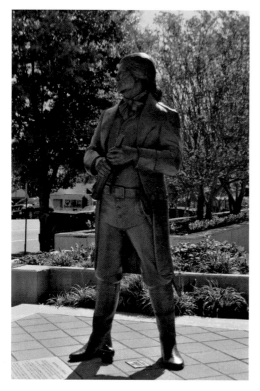

Nathanael Greene never set foot in Greenville, but his legacy gave the city its name. *Courtesy of John Boyanoski archives.*

simply known as "The Street." What is now known as McBee Avenue was "The Avenue." Lots were laid out, and renderings called for a courthouse and a jail. If anything, it shows that community leaders have always embraced the town being about planning. It soon became known as Greeneville, taking its name from the Revolutionary War hero Nathanael Greene. The additional "e" was eventually dropped, and while a log jail and courthouse were built, not much came from the rest of Alston's vision. At least, not until Vardry McBee of Lincolnton, North Carolina, purchased Alston's shares in 1815.

McBee sold real estate, formed partnerships with newcomers in new businesses and brought in trained tradesmen, including harness and saddle makers, brick makers, millwrights, carriage makers and house builders. Greenville quickly grew from a near-forgotten village into a town. Greenville was a trading center for nearby counties but gained its first wave of growth in the 1820s and 1830s, when Lowcountry residents would come to the Upstate via stagecoach for the summer to escape the heat, humidity and malaria outbreaks. The downtown area saw the majority of the growth as famed architect Robert Mills built a new courthouse in the 1850s, and Furman University and the Southern Baptist Theological Seminary set up their schools in Greenville. During the Civil War, Greenville was used as an armory to manufacture rifles—another sign of the city's growing industrial base. Four years after the war, Greenville became a city.

Greenville's first official mayor was Thomas Gower, who ran on a platform of bridging the Reedy River at Main Street in 1870. A bridge still spans the river in that spot. Railroads crisscrossed the area, and the first

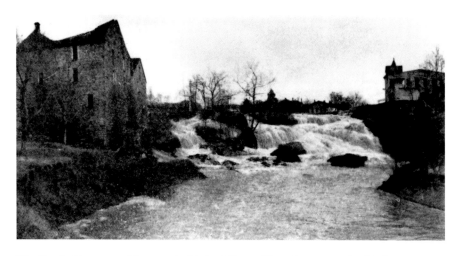

The Reedy River waterfalls were the birth of Greenville and a source of pride for more than 150 years. *Courtesy of the City of Greenville.*

of the great textile mills—Camperdown—was constructed on the banks of the Reedy. Spurred by the growth of textiles, Greenville's downtown boomed in the late 1800s and early 1900s in much the way downtowns everywhere grew into urban centers. Greenville had electric streetcars, Southern Bell telephone service, Coca-Cola and American Cigar production. The falls area was Greenville's pride as people picnicked and enjoyed leisurely Sundays. The construction of the Ottaray Hotel, along with numerous shops and stores, created the business district. The West End became the warehouse district. Textile mills were soon popping up on the banks of the river, creating Greenville's business lifeblood and its most famed moniker. Greenville became known as the "Textile Capital of the South," and eventually "South" became "World."

Greenville's downtown was humming right along through the 1950s and 1960s. Every department store was downtown, as were Greenville's five movie theaters. Everyone has distinct memories of Christmas parades, the glowing of the Poinsett Hotel or eating at the gold-clothed tables at the Downtowner Motel. Bo Aughtry recalled the moose head on the wall and the smell of oiled baseball gloves at O'Neal Williams, a sporting goods store on Main Street. "You could buy everything from Browning to Rawlings in there," he said, comparing the popular hunting rifle brand to Major League Baseball's official spheroid.

Greenville's downtown was in its prime, but the landscape started to change in the 1960s and early 1970s. Greenville was expanding away from its urban

Growing up in Greenville, I took the bus downtown often. It gives me a good perspective. When I see the Mast General, I think about the old Meyers-Arnold department store. I still can see the old movie theaters in my mind. My brother and I climbed the stairs of the old Woodside Building and then did the same at the Daniel Building when it was still under construction. One thing, though, I don't remember is the falls or much of the river. That's not a place you went unless you had a good explanation.

—*Knox White*

core. Furman University moved out of downtown and up near Travelers Rest. People could shop malls on Wade Hampton Boulevard and Pleasantburg Drive instead of on Main Street. Actually, the Pleasantburg Drive area had once been considered the edge of downtown but morphed into a hub with the opening of McAlister Square Mall in the late 1960s. Aughtry remembered being blown away by the size of the building for a town as small as Greenville. People were living in the suburbs. Interstate 85 took people in other directions. However, many in downtown weren't seeing any problems. Noted Greenville historian Judith Bainbridge said two economic development studies in 1962 and 1968 pretty much affirmed that Greenville's downtown was doing just swell. Part of the reason was a shortsighted yet long-term savior of Greenville's architecture. People felt Main Street looked old and dated in the late 1950s, which led to numerous building getting new, "modern" veneers of linoleum aluminum. It looked "good," even as downtown stores began to close. White said everything was about being modern and tearing down the old. He vividly remembers orange carpeting and painful-to-sit-in metal chairs when visiting city hall as a teen. Bainbridge said while hiding downtown's beautiful architecture for years was a negative, it did preserve much of it for the later revival. Still, the bus system shut down. The Reedy River was polluted as dyes from the textile plants upstream filled it every afternoon. It became known as the "Rainbow Reedy" because of all the different colors floating along it. Like many other cities, Greenville's downtown was dying. When Daniel built his tower, he was making a point—a point that preceded a major economic collapse but one that stayed with Greenville. "It really was a reminder. It was a finger pointing right at downtown not to forget what it could be," Knox White said.

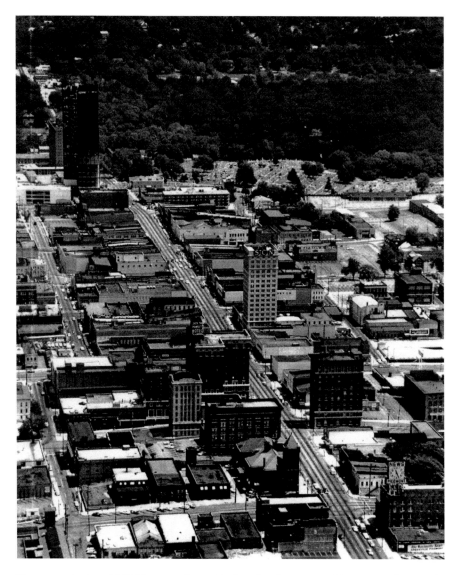

Downtown in the mid-1960s—a perfect grid of steel and concrete with no trees. *Courtesy of the City of Greenville.*

Greenville and many other cities nationwide, though, were not seeing opportunities. Many downtowns were doing things like downtown malls or putting up walls around new buildings. Downtown infrastructure during that era was not pretty. It was not good. It was bad. Like many cities, Greenville was not immune to demolishing classic buildings from bygone eras. While

much of that demolition is warranted, many times it leaves people feeling like something has been lost. In Greenville, that feeling of loss is most felt with the following five buildings.

OLD CITY HALL was located at the corner of Broad and Main Streets. This structure was built in 1892 as Greenville's main post office. It was converted to city hall in 1938 and held that status until 1973. It was demolished as part of the building of the new city hall, and for a brief amount of time both buildings stood. It should be noted that its demolition was done by some of the same city leaders, including Heller, who a few years later led the revitalization effort. In addition, at one point, a plan was floated to move city hall completely off Main Street and out to Heritage Green. The building was known for its large corner tower and terra cotta stylings that made it resemble the Smithsonian Institute's main building. For decades after its demolition, the site was an underused plaza next to the current city hall. It is now Main@Broad, which includes a Marriott hotel and offices for Duke Energy, among others.

The WOODSIDE BUILDING was a Main Street fixture from 1923 through 1975. At seventeen stories, it was the tallest building in South Carolina when it was completed for a cost of $1.5 million. It was on the block between McBee and Washington Streets. It was demolished and replaced by a ten-story building.

TEXTILE HALL was concrete proof of Greenville's industrial might. It was built in 1917 to hold the Southern Textile Exposition, one of the largest textiles shows in the world. By 1962, more than 450 vendors and 30,000 visitors packed the structure on West Washington Street. Realizing more space was needed, a modern textile hall was built away from downtown for the 1964 show. Textile Hall, which also hosted a massive annual basketball tournament, was demolished in 1991.

The OTTARAY HOTEL was Greenville's first modern super hotel. With its semicircle grand entrance on Main Street and eighty-three rooms, the hotel was the first major downtown structure not built at Court Square. It eventually fell victim to the competition from the Poinsett Hotel and met the wrecking ball in 1962. It stood roughly where the Hyatt is now located.

The old WOOLWORTH'S was the site of a peaceful 1963 sit-in that helped integrate Greenville—a historic moment to which many in Greenville point as proof of the city leaders' ability to be forward-thinking. That being said, Woolworth's closed the historic store at the corner of Main and Washington Streets in 1991. Despite some efforts and ideas to get new business in there, it became abundantly clear that the structure needed to go. It was demolished in 2009. A modern tower called "One" is going on its footprint. A statue honoring Sterling High students is located at the corner.

The One Tower is helping reshape Greenville's urban core for the future. *Courtesy of John Boyanoski archives.*

Of course, not everything met with the wrecking ball when progress moved in. The following are five historic building that have survived.

The LIBERTY BUILDING is a ten-story structure that is sometimes called the Chamber of Commerce Building because that was tenant *numero uno* when it opened in 1925 (even though the Roman numerals on the cornerstone state 1924). However, the pesky Great Depression got in the way, and in 1931, locally owned Liberty Life Insurance Company took over as the chamber vacated. Liberty Life eventually became one of the largest companies in the Southeast. Liberty Life moved to a much bigger facility in the county in 1968, but the building has remained a very viable piece of property since.

The AMERICAN CIGAR FACTORY was Greenville's first attempt at diversifying the economy when it opened in 1903. In a world dominated by textiles, Greenville's leaders opened a cigar factory about ninety years before Claudia Schiffer appeared on the cover of *Cigar Aficionado* magazine. It was the first factory to import Cuban tobacco but went out of business in the 1930s. However, it became home to Stone Manufacturing in 1933 and, many decades later, the headquarters of Umbro. It went vacant in 1994 but was renovated by modern textile leader Mark Kent in the late 1990s.

The HUGUENOT MILL is the only existing mill still in downtown Greenville. Of course, it is no longer an active mill and is now part of the Peace Center complex. It faces Broad Street near the River Street Bridge. It is used for events and galas. Built in 1892, it was actually a steam- (not water-) powered mill, and its distinctive tower was for ventilation.

> Greenville's downtown was dying in the early 1970s as the department stores moved to McAlister Square. But one of my earliest political heroes was Cooper White (no relation), who ran for mayor on the platform of doing something about it. He dared to use the word "plan," which was code for fighting back then. I was only fifteen, but I worked on his campaign because his message appealed to me. Later, Max asked me to serve as chairman of his youth advisory committee. So I had exposure to those who were determined to resist the tide running against downtowns. Greenville was almost unique in that we never gave up on our Main Street.
>
> —*Knox White*

The POINSETT HOTEL, Greenville's most beloved hotel, survived almost twenty years of neglect to come back strong in the 2000s. But more on that in a later chapter.

The GREENVILLE COUNTY COURTHOUSE/FAMILY COURT building opened in 1918 on Court Square (where all previous Greenville courthouses were located). This Beaux-Arts structure has quite a history. In 1947, it was the site of the infamous Willie Earle trial, where a band of white men were found not guilty of lynching a black male who was accused of killing a white cab driver. The case drew national attention, as it was the last racial lynching in South Carolina. The building later served as the family court building from 1950 through 1991, and it is not uncommon to hear longtime Greenvillians call going there the happiest day in their lives because they got divorce decrees.

Chapter 2
The Vision and the Roadmap

W hile BMW are the three little letters that transformed the South Carolina economy in the mid-1990s, it is three other letters that have played a greater role than most people realize in the revitalization of downtown Greenville: LDR.

LDR International, short for Land Design/Research, was the Maryland-based consulting firm that was hired by Greenville in the late 1970s to study downtown—where it was going and where it needed to go. It was brought back in the late 1980s to do the same. This was the report that stated that, while downtown was doing well, it had mountains higher than Paris to climb and rivers wider than Reedy to cross before becoming anything close to a destination. In 1989, LDR helped create a vision for the future of downtown—a goal to be hailed nationally as a state-of-the-art community, which would serve, in and of itself, as a national attraction. While things such as the Hyatt, the new downtown transit a station, the Peace Center, the Coffee Street renovation and the Duke Power building had been successes, according to the report, there was a lack of parking; there were high office and residential vacancies, a dearth of major retailers, a tepid nightlife, no focus, no theme and poor linkages.

In 1997, less than two years into Knox White's first term as mayor, LDR came back to town at his request and urging. Greenville's Main Street was doing well, but White felt development was walking a fine line between going in the right direction and falling into an abyss of unplanned ideas. For all of the positives, he wondered if downtown was on the *right* track or some other

track. "I felt we needed a plan," White said. This time, LDR's report would become the all-encompassing blueprint for what Greenville would become. It was like a doctor's visit for downtown where the patient still had the same health problems as a decade before.

Clocking in at forty pages, the LDR report's cover offers insight into what downtown Greenville was deemed to be in the late 1990s. It is a panoramic, aerial photo showing it in its massiveness. City hall is the center point of the photo, but office towers pop off the page everywhere. Landmark. The Liberty Square Towers. The Liberty Building. The Bank of America tower. The Peace Center. The Greenville News building. Bowater. Paris Mountain is a faint sight in the background, but that tells the story. In 1997, Greenville was a business town. Downtown didn't have people walking Main Street. It didn't have accolades. It didn't have residents living downtown.

But that's what the LDR report noted, and it gave tips on how Greenville could make a strategy for the twenty-first century. Greenville's downtown had seen private and public investment in the past seven years—even getting a major story in *Southern Living* dubbed "Remaking Main Street"—but the report posted a less than rosy picture. "There is still concern about the future of downtown. Greenville has to maintain the positive momentum that currently exists," the report noted based on interviews with more than sixty Greenvillians,

In 1997, we needed a new road map for downtown development. I felt that too many bad decisions were being made. The city was still too reactive instead of proactive. LDR gave us a snapshot of what we were doing right and wrong and some very specific advice on what we must do next to have a truly great downtown. We needed to focus on mixed use, especially residential and retail. Downtown needed elements of "personality," such as public art, fountains, et cetera, and other things to enhance the pedestrian experience. And we needed a "major attraction." In 1997, we had very few of these things; even achieving the "major attraction" seemed too impossible at the time. That, of course, would be the restoration of the Reedy River Falls and development along the river. The best part is that everything we did was authentically Greenville—building on our unique assets.

—*Knox White*

who "complained about a variety of things: progress was too slow; the city wasn't doing all it could; some private property owners were restricting progress; not enough emphasis is being given to housing, retail, or office development; and about personality conflicts."

It is interesting to see when, where and how the LDR report pops up in downtown places. Economic development director Nancy Whitworth keeps a copy in her office and cites it often, but it may come as a surprise that restaurateur Carl Sobocinski also has a copy in his office amidst framed newspaper clippings of his Table 301's many achievements.

Whitworth said the LDR relationship was special for the city because the group had been involved for so many years in so many ways. "They were visionary but practical," she said.

Chris Stone of the Greenville Convention and Visitors Bureau said the LDR plan was very unique because of the relationship that was built with the city. Most cities create a plan, but they never implement it. Greenville was able to implement its plan for a lot of reasons, but a major part was the trust with LDR, Stone said.

"The most thing important thing about LDR was they were a third-party firm. They didn't live here every day so they could say things and do things that sometimes were tough. The things that locally couldn't be said. They knew what was successful and what was challenging. To the credit again of the community is the plan became bigger than individuals. It became a road map. We have an assignment. And we need to make accomplishments," Stone said.

The report is interesting for a lot of reasons; many things that had been started that had been proposed in 1989, including reexamining Piazza Bergamo, creating a plan for infill development, improving linkages off Main Street and more, were deemed "partially complete." Things such as creating a major design competition to build a "coliseum" were deemed no longer valid because they had been done in an alternate fashion (in the coliseum's case, with the Bi-Lo Center). Interestingly, demolition of the Camperdown Bridge was seen as no longer necessary. White was actually called up by an LDR official to say the group felt the bridge needed to be removed in order to free the falls, but there was too much community and leadership pushback at that time. The report also takes the city to task for not developing a greenway and parkway plan.

Still, the report notes that the potential to be a truly great downtown on a national scale remained. It was a question of action. It was clear that things had not been moving rapidly since 1989. Was more of the same expected? The plan called for some specific steps:

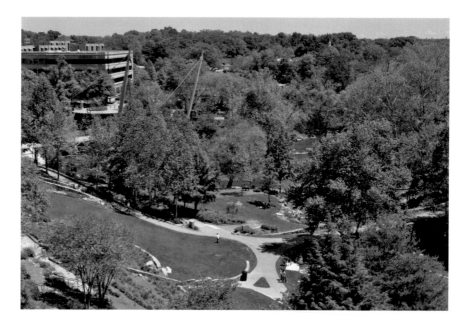

Falls Park helped transform the West End and all of downtown. *Courtesy of John Boyanoski archives.*

1) Make downtown everyone's neighborhood. That actually was a tagline offered by LDR: "Downtown as everyone's neighborhood." Peeling back the layers of that onion, though, it meant to make downtown feel like a safe, inviting place, a place that people want to take care of. While the "neighborhood" motto never made it off the back burner, Greenville created a neighborhood feel. It's why visitors can ask for directions and suggestions on where to eat and get answers from Greenvillians. It's why people pick up the trash and stuff it in black metal garbage cans. It's why people flood Greenville Cares (the city's hotline for complaints) with ideas.

2) Create a new downtown attraction. Of any proposal, this one had the potential to be a trap. Remember, cities were thinking up gimmicks to get people to come to their downtowns. Greenville was tasked with creating something unique that had broad appeal to everyone. Themes such as science technology, manufacturing and history were suggested, but the ideas were quickly forgotten. The one, though, that got the push was a green, ecological pursuit. Specifically, the Reedy River. That plan would lead to Falls Park and the Liberty Bridge.

3) Housing. This was dubbed an "essential ingredient for success." To say the least, this has been taken to heart. Since 1997, downtown has added more than one thousand units of housing, whether as apartments, condos or full-

on houses. It also got full scale. In the 1990s, it was pioneers like Courtney Shives and Henry Holseberg building units, but these were in small spurts. The 2000s, in part because of LDR, would see massive numbers of units built at one time. White said the big takeaway was that the city had to be proactive and promote housing. It needed to encourage and respect people like Shives and Holseberg.

4) Retail. This might have been the toughest task, at least in the eyes of people in 1997. Greenville's shopping districts had long ago moved out to Pleasantburg Drive and Haywood Road and centered on major malls. At least they were still on the city tax rolls. The reality was that Woodruff Road was soon to become the next shopping destination, and the majority of its business was in the county. And since so many of those areas had the major retailers and big-box stores, Greenville would have to get creative when looking for retail.

5) Get a personality. What does this mean? The report is actually very vague but offers the idea of playing up a "green" image. Or maybe more of an international flair via a sister city program. However, whatever was chosen, it had to feel authentic.

While those were the major driving points, other interesting nuggets of this dream would come to life over time and in unexpected ways:

1) The plan predicted that Greenville would become a tourism hub, and this would aid economic development. While the plan focused on business and conferences, downtown has become a vibrant weekend destination for out-of-towners. Developer Bo Aughtry remarked that he doesn't have any scientific research, but he encounters enough people in the lobbies of the two hotels he built downtown to see that Greenville is a destination for people from the surrounding region.

2) A downtown trolley loop. While originally seen as an extension of the bus system to incorporate quick routes, it has become a free weekend trolley system that started because of the Greenville Drive arriving in the West End in 2006.

3) Mixed-used parking garages. Considered a novel idea at the time, all new city garages now have some kind of retail/office/housing space attached to make them less monolithic.

4) Redesigning City Hall Plaza. The plan called for public space at the corner, but it has become so much more. That corner (Broad and Main, next to city hall) now houses the Marriott, as well as a public green space that doubles as an outdoor skating rink in the winter.

5) Expanded city management of downtown. This led to the creation of a downtown manager position, as well as numerous design and review boards that help keep up standards.

The report concludes with an almost prophetic paragraph: "It can be the 'in place' for residents of the city, the county and the region. It can be the focal point of economic development for the Upstate area. Meeting the challenges identified in this report card assessment and implanting the suggested strategies."

Mayor White said this study had a profound effect on him at the time because he was starting to immerse himself in the idea of downtown being more than just walls, buildings and cars. It had to be pedestrian friendly and unique. He was going to conferences and reading book after book about what could make Greenville better. He soon became an admirer of author and urbanist Jane Jacobs.

A native of Scranton, Pennsylvania, Jacobs was preaching that urban areas were not conducive to urban dwellers. She was the first person to challenge the status quo in 1960. She said downtowns needed to be pedestrian-friendly. They needed mixed-use developments that blended offices, retail and residential units. Jacobs had likely never heard of Greenville, but her teachings were heard and used by Knox White years later. Amid the souvenirs and accolades of downtown redevelopment in his office on the tenth floor of city hall, White keeps a copy of Jacob's book *The Death and Life of Great American Cities*. He notes:

> *Jane Jacobs turned urban planning upside down, but her ideas are all the norm now. In the 1960s and 1970s, it was all about big mega projects and urban renewal. She proposed a different strategy—one that focuses on people and walkable neighborhoods and mixed use. Our wide sidewalks and pedestrian feel speak to this. I read and reread everything she wrote and how to apply her thinking to downtown and even other areas of our city.*

A second major influence on White was Bert Winterbottom. A native of Glendale, California, Winterbottom received a bachelor's degree from Illinois State University in 1958 and a master's degree in public administration from the University of North Carolina in 1974. He came to Greenville to serve as the planning director. He left for Maryland in the late 1970s to work as vice-president for the Greater Baltimore Committee. He was vice-president of the American City Corporation of the Rouse Company from 1979 to 1985, when he joined LDR International, Inc. It was from there that he directed worldwide tourism development strategies and plans, urban design projects and strategic planning for an array of public and private clients.

Charismatic and a people person, he never lost his eye for Greenville, White said, which was a major reason he helped lead the 1997 LDR plan. It was he who called White to tell him about the bridge demolition being deemed "no longer valid" in the report, but the reality was that it needed to be taken down. While committees and task forces sat to talk, Winterbottom grabbed White and would take him for a walk. White recalls:

> Bert taught me the power of observation. We walked downtown from end-to-end. And he tutored me on what he saw. He would ask, "How do you feel standing here? How can you make this corner or this block more pleasing to pedestrians." He gave life to ideas like connectivity, pedestrian orientation and the urban fabric. Bert didn't mind pointing out where Greenville had gone off track and what we needed to do. He did so with a real passion because he loved our city and he knew it so well. He also urged me as mayor to become the chief advocate for good urban design and to never stop observing. He knew downtown Greenville had the potential to be world class. He saw that we were on a good track, but in his view we had gotten off track on some key things.

Winterbottom would never see his vision for Greenville come to fruition. He died from cancer in December 1998.

It's obvious that planning and sticking to plans are a hallmark of Greenville's downtown growth, but LDR is not the only plan that helped shape what Greenville residents see of downtown. The following are some others.

The Reedy River Master Plan was created in 2002 in part because of some public backlash about the city always going to consultants outside the region for ideas/plans. Why not tap the acclaimed university up the road? Actually funded by the city and county, this plan outlined strategic ways for the areas along the river to be redeveloped. One of the key initiatives of the plan was a trail system that in part helped spur interest in the Greenville Hospital Swamp Rabbit Trail.

Implemented in 2008, the Sasaki Plan is helping guide Greenville's growth over the next twenty years. It includes the idea of creating five key corners of downtown to enhance entranceways and the overall feel.

While not specifically about downtown, Vision 2005, a community-wide envisioning process led by Max Heller, helped create a plan for the Peace Center and the Bi-Lo Center. An updated, rebooted version of the plan is called Vision 2025.

And it all comes back to LDR, Winterbottom and a mayor with a law degree who became a student and advocate of new urban design. White notes:

The diagnosis was we were missing some things that were preventing us from achieving real greatness. If we do these things, we can go to another level. That is the interesting thing a lot of people just don't get. We could have stayed on the bad path, so to speak, but LDR gave us a wonderful road map. And that is all we have been trying to do, follow the road map. We have had a lot of luck on the way. We also had plenty of serendipitous things that we weren't expecting. That is what makes it interesting.

First Steps

K nox White's election to city council ran a distant third in the biggest news category for his extended family in early May 1983. Number one on the list is open to debate, depending on who is telling the story, but that week saw White marry his fiancée Marsha, whom he had met while both were Washington, D.C. congressional staffers.

It also saw the naming of the federal courthouse in downtown Greenville after appeals court justice Clement Haynsworth, one of Knox's uncles on his mother's side and whose last name is the same as Knox's middle name. Then there was Knox actually getting elected, something for which he held off his honeymoon for two weeks to accomplish.

And none of these things actually captured the real story.

Knox White's political career started with what essentially amounted to a kidnapping. Yes, White had been politically active for years and served as a one-man volunteer staff while in high school for fellow Greenvillian Carroll Campbell's (a later congressman and governor) early political campaigns. He later served on Campbell's congressional staff after law school but moved back to Greenville at age twenty-eight to focus on his law career and his upcoming wedding in April 1983. He figured politics was in his future, but not now; that is, until a car pulled up to him as he tried to cross Church Street one morning. Before he realized it, he was pulled into the back seat and held down. Pinned down in the seat, he was surprised to realize his kidnappers were Tim Brett and Jerry Dubois, two fellow Campbell political operatives. They had been tasked with finding a Republican to run in a special city

election that spring to fill a vacant at-large seat. Getting desperate, they spotted White and immediately knew he was their guy. White protested that he was getting married a few days before the election. They shrugged this off, saying if he didn't say yes he was not getting out of the car. "Yeah, that really happened," White said, "but I still wasn't sure. I then met with Bill Workman, and he laid out his vision for Greenville and I liked it. I wanted to be part of it, so I ran."

Workman actually held the seat that White was running for but gave it up when he won the Republican nomination for mayor in 1983. That opened the final two years of the seat's term, and White ran against Bob Scales, a retired Liberty Life executive and former chairman of the Greenville County Democratic Party. The campaign focused mainly on young versus old, as both men agreed that economic development was key, along with work on the Donaldson Center and expanding city limits.

White won 2,627 to 1,368 to take the seat. He joined a city council filled with a group of young turks under age thirty-five: David Thomas, who later became a state senator; Lillian Brock Flemming, who would eventually be the longest-serving council member in Greenville history; and Terry Haskins, who later served in the state House, including five years as Speaker pro tem.

However, it was the newly elected mayor, Bill Workman, who was making the biggest impacts and changes in 1983 from a governmental side. Upon taking office that June, he made two very bold decisions/statements that would alter city development for years. The first was that he was not going to be a full-time mayor like Heller had been. The second was that he was going to place a lot more of what the city would do in the hands of the young council members.

While his story is not nearly as recounted as Heller's, Workman brought a very interesting life and career to his time as mayor. His mother was an English professor at Columbia College. His father had been a writer for *Newsweek* and a capital correspondent for various newspapers before becoming editor of the *State* newspaper. His father also was a Republican and ran unsuccessfully for the senate and governor's office, but he taught his son the necessity of economic development. That was something that would assist Workman later on. And like his father, Workman graduated from The Citadel and initially went into a career as a newspaperman, which brought him to Greenville in 1966, when he landed a job as a reporter at the *News*. However, he began teaching part time at Greenville Technical College. That led to a career change; he would become the school's dean of health sciences and later served as executive assistant to Governor James Edwards. Still later,

he would hold high-up positions at Fluor Daniel and Piedmont Natural Gas. Along the way, he started a career in politics, serving on the school board from 1969 to 1975 before being elected to the city council in 1981. And while he was a Columbia native, he spent many summers at a YMCA camp in Greenville and had a certain affection and love for the region.

He was a big picture guy who focused on long-term economic development projects. "He deserves a lot of credit for what happened," said Minor Shaw, whose community involvement ranges from helping bring the Junior League headquarters downtown in the 1980s to serving the Greenville-Spartanburg International Airport today.

Shaw brought an interesting perspective to what was happening in the 1980s. Her father was Buck Mickel, one of the true titans of Greenville business for generations. He followed Charles Daniel as president of Daniel Corporation after the latter's death in 1965, and it was he who oversaw completion of the company's downtown tower. Like many of her generation, Shaw left Greenville for college in the 1960s and didn't come back until 1979, when her husband, Harold, joined a medical practice here. The first vestiges of growth were occurring, but it was very slow. She remembers a showroom on the second floor of a downtown building above a tearoom that was created to show people what a downtown condo or apartment could look like. It was a visionary idea, but it was a little ahead of its time.

"Even with the Hyatt, people still weren't coming downtown," she said.

The early to mid-1980s were a difficult growing time for downtown, but many still weren't sure what to expect of redevelopment. The Hyatt had opened, the sidewalks had expanded and Main Street was lessened to two lanes. However, it was still pretty much a dead area in terms of shopping, restaurants, residents and amenities. In some ways, planning for the future was chaotic. The 1980s were the transformative era of Greenville's downtown. There were some major wins in the era, including the construction of what are now known as Liberty Square towers on the main drive into downtown off Interstate 385, but there was a lot of moving in slow motion, as it were. There were wins to be had, but many people remained skeptical.

White recalls developer Courtney Shives redoing the Cauble Building at the corner of Main and Coffee Streets in the mid-1980s. At the time, it was an underused building covered in blue siding, but Shives proposed restoring it to its original look from the early 1900s as a bank. He proposed a restaurant on the first floor and housing on the second. White remembers Shives using a flip chart with some flair to show city

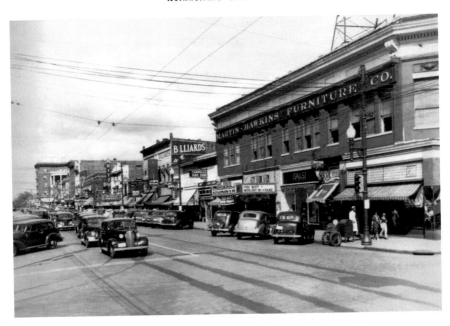

The Cauble Building as it looked in the early 1900s. *Courtesy of the City of Greenville.*

Knox White called the mid-1980s renovation of the Cauble Building the model for future Main Street mixed-use developments. *Courtesy of John Boyanoski archives.*

council his ideas and getting almost no reaction from the group. The city wasn't ready to understand mixed use.

Developer Bob Hughes tells a story of a four-dollar building that underscores how bad-off downtown was at the time. He was at a cocktail party when someone asked him if he could help find the cheapest forty-thousand-square-foot building in Greenville. Hughes imagined a metal building off a dirt road in the middle of nowhere and quickly went to work. He walked across the room—literally—and asked a smart real estate broker where such a cheap building could be. The answer was Main Street. A vacant furniture store could be had for four dollars a square foot.

Bo Aughtry, who would lead the way on two hotel projects and the first major condo unit off Main Street, called Poinsett Corners, in the 2000s, said downtown was a dicey proposition during the 1980s. He was not a fan of Hyatt and thought it would be an economic disaster.

Nancy Whitworth, who was working in the city economic development office during the decade, said a lot of it had to do with a lack of cohesive vision. There were a lot of people interested in downtown's revitalization, but they weren't exactly working together. It was not out of spite or any problems, she said, but things never seemed to gel. That is typical, though.

"When you begin something, everyone gets all in and excited. Then you get into feeling that nothing is happening as fast as people thought, so a lot of enthusiasm wanes. It was a little bit of 'Well, now what?' The key was to keep focused on the fundamentals and keep engaged. That is when we began to look at what's next," Whitworth said.

Those fundamentals were a lot of small things being done that would play major roles down the road. Zoning laws were changed that would allow for mixed-use development. Efforts to keep the downtown streets clean, as well as added law enforcement, started. Code enforcement began to not just protect buildings but also make sure future buildings jived with the feel of downtown. Historic preservation became a key issue as the entire West End was turned into a historic district to help preserve it.

"The devil is in the details," Whitworth said. "You can have a great vision. You can have a great strategy. But if you don't have the ability to execute it, and execute it from all different angles, then I don't think it will ever be quite as successful. It's not quite so simple."

In 1981, a group called Crane and Associates created a ten-year plan that would lay out the goals for the next decade. That plan would lead to a group called the Greenville Central Area Partnership (GCAP), which would serve as a catalyst, as it were, for most of the decade's major growth.

As a member of city council, I never missed a GCAP meeting. It was an amazing opportunity to glimpse future projects and do a lot of dreaming with like-minded people. Bob Bainbridge made it fun. GCAP members and a few property owners on Main Street saw the potential. Even back then leaders like Larry Estridge talked about removing the Camperdown bridge and bringing resident to downtown. Great ideas but everything was in its infancy as far as implementation.

—*Knox White*

Bob Bainbridge studied architecture and urban planning at the University of California–Berkeley and then did his postgraduate work at Rice University. It was there that he met a professor named Bob Crane, who would later hire Bainbridge for Crane and Associates. This is the group that helped lead the revamping of downtown Boston and created a housing strategy for Atlanta in the late 1970s. Bainbridge was flying all over the country when he landed in Greenville to help with the 1981 downtown study. His reason for staying was, as he put it, "Charleston's fault." Crane got tied up in a project on the coast and started bleeding money from it. Seeing a bad omen for the firm, Bainbridge essentially moved to Greenville in June 1981. He stopped getting paid by Crane in July and lived off credit cards until October before being hired to be the executive director of GCAP.

While Greenville struggled with what to do next, there were some signs of the life that would come down the road. Bainbridge said one of GCAP's goals was to find new ways to get people to come back to downtown after essentially forgetting about it for a decade. Festival and downtown events were the first effort. Fall for Greenville started in 1982 and drew about 20,000 people to Main Street on a Sunday afternoon. This three-day festival now draws about 250,000 annually. Bainbridge said after the first year that he personally filed an application for a Sunday alcohol license—something completely unheard of at the time. He was vilified by local church groups and basically had to publicly guarantee that nothing bad would happen or he would not apply again.

A major concern that GCAP saw was the need to expand the downtown footprint and increase the number of people living there. Bainbridge pointed to Tulsa, Oklahoma, as an example. Its downtown was seeing a rebirth similar to Greenville's but focused heavily on high-rise buildings that helped business but provided no sense of life. "I called it Fort Tulsa. There were no people," Bainbridge said. "After five in the afternoon, it was empty."

There were other small projects that, while almost taken for granted now, helped lay the groundwork for what would come later.

Tommy Wyche led a group of investors to start compiling what would become known as RiverPlace. Wyche actually conceived of the idea in the 1970s but held off until after the Hyatt project was done. In 1986, the *Greenville News* actually reported on RiverPlace for the first time, showing a crude map of the area that called for "festive shops, homes, and restaurants." That plan would not see fruition for more than twenty years. Still, it was laying the groundwork.

One of the most unknown parts of the Greenville rebirth was the creation of a Tax Increment Finance (TIF) district in 1986. This visionary piece of law allowed South Carolina cities to essentially bank tax dollars normally spent on the city, county and school district and use them for economic development projects. Bainbridge said the original legislation for TIFs didn't work, so it had to be changed to allow TIFs to occur. It would be almost impossible for the city (or any city in South Carolina, for that matter) to create such a funding mechanism today because of political rancor, but it was essential in 1984. Jim Bourey, who would serve as city manager for the bulk of the 2000s, said he

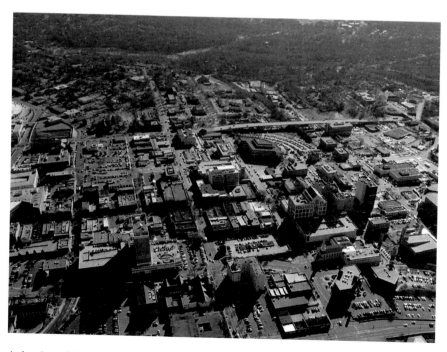

A sky view of downtown in the mid-2000s. *Courtesy of the City of Greenville.*

41

doubted how well Greenville would have done if it weren't for the TIF. It has pumped millions and millions of dollars into downtown and allowed for Greenville to continue to invest when other cities couldn't.

"It made all the difference in the world," he said.

The initial TIF centered on what is called the Central Business District, roughly both sides of Main Street out to Academy on one side and Spring on the other. It also includes land for what would be become the Peace Center and, interestingly enough, Springfield Cemetery. The success of the main TIF led to the creation of a West End TIF in 1987.

There were some construction highlights. A company called U.S. Shelter, which was booming because of its investment in apartment complexes, built what is now known as Liberty Square, a seventeen-story tower and a twelve-story tower with a parking garage in between; this remains one of the first things seen when driving into downtown. The Commerce Club opened on the highest floor of the taller building and became one of Greenville's first real dining attractions. Built in the early 1980s, U.S. Shelter planned for a third tower but never got around to it. Instead, that land became a 68,000-square-foot office building at the corner of Main and Beattie Streets and solidified development on that part of Main Street for two decades. New restaurants began to pop up. The Broad Street connector was created that linked the south end of Main Street to the Hampton Pinckney district. Life came back to downtown in small spurts. Several housing projects were started on the outskirts of the Central Business District. The Falls Place building on the edge of the Reedy River Falls was restored. Between 1981 and 1985, downtown saw the number of workers increase from 8,500 to 13,000, the office market went from 1.1 million square feet to 2.1 million square feet and more than $120 million was put into real estate development.

And there were fallbacks and plans that never came to fruition. A countywide vote to pay for a new downtown "coliseum" was repeatedly shot down by the electorate. The tree planting rarely expanded beyond the Main Street core, which hurt efforts to make the downtown area feel larger. An example was a condensed Bi-Lo grocery store built at the corner of Main Street and Park Avenue. While physically on Main Street and a few blocks from the Hyatt, it never really took its place as part of downtown—so much so that, twenty years later, when a Publix supermarket came downtown, most residents hailed it as the first grocery store. Whitworth remembers the city allowing numerous buildings in the West End to be bulldozed in the early 1980s, which, while seen as a good idea at first, was quickly realized to have robbed the area of its historic look.

However, the late 1980s saw a major shift in the direction of what downtown would become, but it came at the expense of GCAP. "When you look at how cities and particularly how downtown development is done, every place is different. I think one of the things that was perhaps a little difficult in Greenville for GCAP was it was private. I don't think from a city standpoint we were quite as engaged as we should have been," Whitworth said.

In 1985, city council appointed a citizen's committee to begin looking at the idea of a large-scale performing arts center downtown. Such plans were not new—as early as 1907, a city-planning study called for a performing arts center along the Reedy River—but the mid-1980s finally saw a concerted effort to actually build something. The committee hired C.W. Shaver, Inc., to conduct a feasibility study. A unique public-private fundraising partnership was created for such a center. And three branches of Greenville's Peace family kicked off a capital fund drive, pledging $10 million in memory of Roger C. Peace, B.H. Peace Jr. and Frances Peace Graham—no strings attached. It was generally considered that the center would go on the river, but an actual location was debated for some time before a six-acre site at the corner of Main and Broad Streets, where three deteriorating buildings provided an example of urban blight, was decided upon. The Peace Center was designed by Craig, Gaulden and Davis, a local architectural firm, with the input of nationally recognized acoustician Larry Kirkegaard and theatrical design firm Jerit/Boys.

To preserve Greenville's heritage, those deteriorating buildings were incorporated into the complex. The former C.F. Sauer (Duke's Mayonnaise) became an outdoor venue known as the Wyche Pavilion, and the Huguenot Mill building became more added event space. The initiative began to gain momentum in the community. In 1989, a local arts advocate named Dorothy Hipp Gunter pledged $3 million for the four-hundred-seat theater that bears her name. Gunter also made a separate donation to purchase one of two Steinway pianos for the two halls. The community took notice, and soon everyone began pitching in. One example was the "88 Keys Campaign: 88 cents for 88 keys in 1988," in which donations were made by thousands of schoolchildren (eighty-eight cents apiece) to purchase the second Steinway. In addition, the city contributed $6.4 million, the County $1.25 million and the state $6 million, but still, 70 percent of the $42 million raised to build the Peace Center came from the private sector.

In November 1990, the five-year effort culminated in a weekend gala celebrating the completion of the complex. It was unlike anything Greenville

had ever seen. While the Hyatt had seen little fanfare when it opened, the Peace Center opening was a black-tie event that caused *Greenville News* writer Deb Richardson Moore to lead her story on the opening with: "All that glitters is not necessarily gold. Diamonds and rhinestones glitter, for instance. So can operatic arias and piano concertos and Broadway show tunes and carved dragons of ice." The Peace Center opening was more like a Hollywood premier than something from a sleepy southern town. Even a small fire on the morning of the grand opening caused alarm (literally) when a curtain caught flame but could not extinguish the spirit of what was happening. Approximately 1,500 guests paying $200 to $250 for benefit tickets entered on red carpet as fake cardboard paparazzi were stationed to make it look like pictures were being taken. Extravagant bars and food tables were set up in the lobbies of both halls, as well as on the stage of the next-door Dorothy Gunter Theatre. Catered by the Greenville-Spartanburg Airport Marriott and the Nippon Center Yagoto, the heavy hors d'oeuvre menu consisted of such delicacies as baby lamb chops, miniature chicken cordon bleu, lobster topped with caviar and sushi. Sally Jessy Raphael, then one of the biggest stars on daytime television, was the emcee. Former Greenvillians Sarah Reese and Mimi Wyche and Greenwood native Nat Chandler joined a host of performers that opening weekend. While Reese sparkled in diva-esque grace, and flew back after her Greenville show to appear on Broadway and then flew back to Greenville for a second night, it was Wyche who captured the humor of downtown. She came on stage hauling a pine tree, saying she was looking for the Memorial Auditorium, before launching into a series of songs backed by the Greenville Symphony. She then joined Chandler in a duet from Andre Lloyd Weber's *Phantom of the Opera*. Wyche told the *Greenville News* that night, "You leave your hometown with dreams of performing in some spectacular hall—your idea of what Oz is...Then you realize, it's home. In this case, Oz is in Greenville. Because it's just so gorgeous."

Two years after that grand opening, the Peace Center launched a $6.5 million endowment campaign to help ensure the ongoing operation of this community landmark. In less than two years, the goal was realized. In 2012, the Peace Center underwent a major renovation to ensure that Greenville's growth would continue. Interestingly, the new look has a large plaza from the main glass doors extending out to the curbs of Main and Broad Streets. The original plans for the building had a similar look but were scrapped to have a driveway through the plaza so people could get quick access instead of hanging around downtown. The *Greenville News*

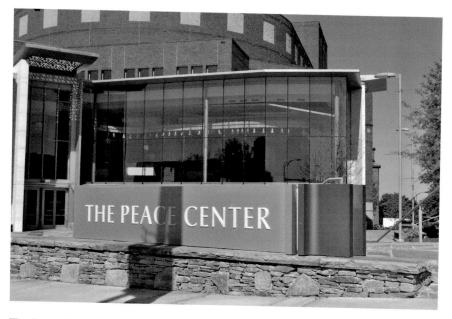

The Peace Center for the Performing Arts was a community-wide project. *Courtesy of John Boyanoski archives.*

would opine twenty years after that grand opening, "The Peace Center is more than a performing arts venue. It is a symbol of Greenville's vision and appetite for big challenges. Today, it is a landmark at the hub of Greenville's celebrated downtown. But it is also a landmark in Greenville history. At a time when things were bad and could have gotten worse, the community said, 'Let's do something remarkable.'"

Alan Ethridge, executive director of the Metropolitan Arts Council, called the Peace Center one of Greenville's biggest assets. Not only does it bring touring Broadway plays and shows, but it also hosts events for the South Carolina Children's Theatre, the Greenville Symphony Orchestra, Carolina Ballet and more. It hosts a wide array of events outside of Broadway that allow it to offer something for everyone in Greenville and the rest of the Upstate region.

"Just look at what that facility has done for the community," Ethridge said.

Through all of this Knox White grew as a city leader, twice being reelected to council. He launched a campaign for the mayor's office in 1995 against Workman, who was in his third term. The campaign started after Workman backed a plan to widen Augusta Road. White was one of the main opponents, along with a host of others, including Garry Coulter, Michelle

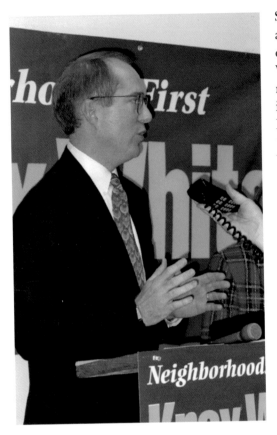

Knox White on election night, 1996. Elected on a platform of protecting neighborhoods, his legacy would become downtown revitalization. *Courtesy of the City of Greenville.*

Shain and Susan Reynolds, all of whom would later serve on city council. But it was White who made the biggest move by taking on Workman in the Republican primary. His campaign slogan was "Neighborhoods First." White won the primary and then defeated Flemming in the overall race. He would face some minor challengers in 1999 and then a write-in candidate in 2003. In 2007 and 2011, he ran essentially unopposed. The reason each campaign got easier is because city successes got stronger. Each campaign had a main project, such as creating Falls Park, seeing a downtown baseball stadium built or reopening the Poinsett Hotel. It would be unfair to call his city hall office a shrine to downtown's accomplishments because it isn't. Yes, there are framed pictures on the walls of the front of the Poinsett and Fluor Field. There is a model of Liberty Bridge. There are books on urban design and pictorial histories of Greenville's sister cities. But it is a working office. His administrative assistants—for years, Arlene Marcley, until she retired, and now Sylvia Fowler—keep boxes in a storeroom that contain old photos, speeches and awards. They don't fit the future. Blueprints and maps are rolled up and ready to be used. There is a constant stream of people calling him on the phone or dropping by to ask questions. Mayor White recalls:

I ran for mayor because I sensed that city residents wanted a better balance between growth and quality of life. My campaign slogan, "Neighborhoods

First," really struck a chord. It meant let's have a city government that put a premium on people living in the city again, that city government should listen more and that we should work harder to make sure our city grew the right way. It was easy then to see that downtown, too, needed a better residential base and that good planning was better than a philosophy of "anything goes." In short, we shouldn't be ashamed to have high standards for Main Street and our neighborhoods.

Chapter 4
Saving the Poinsett

The Poinsett Hotel was the biggest and most prominent challenge that the city faced upon Mayor Knox White's taking office in 1995. It was his top priority from day one. Not just because the grand hotel had been abandoned for years. Not just because it served as a virtual barrier for growth. Not just because downtown Greenville had only two functioning hotels at that point.

No, the Poinsett Hotel was a visual reminder of the hurdles downtown Greenville faced as its revitalization gained momentum. Every time White walked into his wood-paneled offices on the tenth floor of city hall at 206 South Main Street, he had an eye-level view of the aging hotel located at 120 South Main Street. It was the brick-and-mortar symbol of what was not working downtown. The wraparound windows of his office looked directly into the upper portion of the hotel, where he could see the faded red sign on the precipice and the old air raid alarm siren that rang every first Monday of the month when White was a boy before going silent in 1968 due to unavailable repair parts. In a downtown full of concerns, this was the one that looked White in the face. The Reedy River Falls could not be seen. The West End was a world way. There was no art to be seen. But the Poinsett could be seen. There were days in the late 1990s when White felt he could almost touch the building as plans for its rebirth lurched precariously forward during his first term in office. Reopening the Poinsett was about more than a hotel. It was about making a statement about Greenville's past, present and future.

The Poinsett Hotel had a little bit of everything. It had the "handsomest and best furniture money can by" when it opened in 1924. It had a machine that could clean people's change. It had Talluhah Bankhead stay there. It had Jesse Jackson work there as a teen. It had fallen under hard times in the 1970s. It had fallen into disrepair in the 1980s. It had been written off as a ghost of another era, haunting downtown's redevelopment in the 1990s. White said most Greenville business insiders seriously believed the hotel would never reopen again, let alone to the style and grace it had known for decades. The Poinsett was a broken building on the broken side of Main Street. The Hyatt opened in 1982, and development sparked around it. The Peace Center had opened in 1991, but few physical changes had occurred. While White saw the potential, he said many other people overlooked the hotel like it was just a piece of the scenery. He tells a story of taking some out-of-town guests to eat downtown, and they just stopped and stared at the hotel. They couldn't believe this gorgeous building was dark and boarded up on a weekend night on Main Street. It had vanished from people's sight, but not from their hearts and minds.

White recalls:

> *I began to realize just how important the Poinsett was going to be to the revitalization of downtown Greenville. Don't get me wrong, I knew we had to do something there. I knew it couldn't be an eyesore. It really broke up Main Street, and I knew that had to change. Downtown essentially ended at Washington Street. It was like a Berlin Wall. People would just not cross it. We had the Peace Center, but most people would get to Washington and just turn around. To truly revitalize Main Street and to ever reach the river, the Poinsett Hotel had to be brought back.*

Why was the Poinsett Hotel so important? It wasn't just out-of-town visitors looking for another to place to stay. It was the opportunity for White and Greenville's leadership to reengage "old Greenville." While downtown was making strides and getting some notice amongst the younger generations, Greenville's longtime residents didn't see the need. There was nothing of value to them in a handful of condos, some upscale restaurants, street festivals and a few bars. This was not their Greenville—at least, not the Greenville they knew. The Greenville they knew was gone in their eyes. Old City Hall had been demolished in 1973. The big chain stores were gone. The old Woodside Building was gone. The old Greenville News–Piedmont clock at the corner of Main and Broad was gone and scattered in the backyard of

a home of a member of the Peace family. Almost everything of their history was gone and essentially forgotten. Even the Poinsett they knew—the one from Sunday dinners, graduation parties, proms, weddings and more—was gone, just a shell on Main Street with some first-floor tenants.

White said:

> We had to show people that we wanted to incorporate Greenville's past into its future, and really there weren't a lot of opportunities because so much was demolished and gone. Restoring the Poinsett to its former self was one of the last chances we would get. It had to be done right. We started to realize that this was our opportunity to recapture that grandeur.

And what grandeur.

The Poinsett was designed by W.L. Stoddart of New York. Stoddart was often called Stoddard in the southern newspapers that seemed to write every few years about his latest architectural commissions in places such as Atlanta, Charleston, Savannah, Macon, Knoxville, Asheville and Charlotte in the 1910s and '20s. His work was known for its efficiency and style; his other claim to fame had been designing Broadway sets. Terra cotta was prominent. Reddish-brown tapestry brick gave the buildings a refined look. The Poinsett's style reflects all of that, and it can be seen in its sister hotels, such as the Francis Marion in Charleston and the Winecoff in Atlanta. They are somewhat interchangeable in look, but all have different aspects. The Poinsett was built in an L shape, with the top part of the letter pointing to Main Street and the right angle toward Court. Hankin-Conkey Construction started work on the twelve-story structure on the last day of May 1924. The Poinsett (named, of course, after Greenville's early benefactor, Joel Poinsett) was built on top of the former Mansion House site, which had been Greenville's first main downtown hotel in the 1800s. Actually, old photos of Greenville show a series of doughboys standing at attention for an announcement at the courthouse on Main, while a placard on the adjacent vacant lot states that it is the future home of the Poinsett Hotel.

Everything was in place for the next great southern hotel when it opened in June 1925, and yet, it promptly flopped as a destination despite its copper canopy, terrazzo floors, dolphins carved into the wrought-iron railings and exquisite marble work. The hotel was $1.5 million in debt by 1930. In desperation, the owners turned to Mason Alexander, then general manager of the Ottaray Hotel just up Main Street, to manage the hotel. It was a wise choice, as Alexander changed the operations top to bottom for a hotel that

was charging $3.00 per day for a room. He did white-glove inspections of rooms daily and drilled the red-jacketed bellhops on the names of customers so everyone felt they were on a first-name basis, whether it was a local businessman, the mill foreman or such celebrities as Gloria Swanson, Amelia Earhart, John Barrymore and Jack Dempsey, who had all spent the night at the Poinsett by the end of the decade. Even coins were cleaned daily in a special washing machine lest anyone get a bad impression of the hotel. In time, staff referred to Alexander as "Old Admiral Spit and Polish," in equal parts out of admiration, fear and anger. But Alexander had vision. He offered rooftop dining before World War II. By 1946, the Poinsett was dubbed the best mid-sized stay-over in the nation. A 1947 *New Yorker* article called it "cleaner and more comfortable and kinder to the appetite than most of the great New York hotels." The 1948 hotel menu included Roast Prime Rib of Beef for $2.25, frog legs sauté for the same price, ham knuckles and sauerkraut for $0.95 cents and quarter-priced salads. For dessert, try the green apple pie and wash it all down with a bottle of champagne for the sum of $4.75—the most expensive thing on the menu. If you were lucky, you might catch a young Liberace banging away on the dining room piano when he was in town.

A hotel magnate from Texas named Charles Sammons bought the controlling interest from Alester G. Furman in 1959 and made the

The Poinsett Hotel was a Greenville landmark for generations. *Courtesy of the City of Greenville.*

Poinsett part of the Jack Tar brand of hotels. A *Greenville News* editorial at the time started with the words: "Most Greenvillians don't know who Charles Sammons is, but he needs to know that he just bought the heart and soul of our city." The message was clear: don't screw up. The Jack Tar name would be added to the building via a large red-lettered signed that still glows, but motels on the highways soon became the place to stay for cheap in Greenville. The number of rental rooms doubled from 1,660 to 3,300 during the 1960s. The Poinsett management even integrated in 1964, to no avail. The competition was everywhere and cheaper. It remained a political stop, of course. Strom Thurmond would use the hotel as a base of operations on campaigns in the Upstate—going for a brisk walk in the morning before getting the newspaper, sweet rolls and coffee delivered to his room—but that didn't bring the crowds back. Even a stay by Robert F. Kennedy could not generate interest in a modern world. The hotel was purchased by a new group of owners in 1973. White remembers going there during this time and recalls the pungent odor of cigars in the fabric. About 90 percent of the belongings were auctioned off over three days, and the building was renovated slightly, but it was closed in 1975 because of fire code violations. The remaining staff members were rewarded for their service with items from the hotel such as silver pitchers, but for two years the hotel was dormant.

That is, until a couple named Frank and Ann Bible bought the building in 1977 for $449,000 and reopened it as a hotel for seniors. Frank Bible had managed the Bon Air in Augusta and promised bingo nights, billiards and access to movies and libraries for seniors. City economic development director Nancy Whitworth remembers a conference there during her first year with the city in 1979. "It was in pitiful shape. I remember the drapes. They were in tatters. It was a nightmare." Years later, while trying to get developers interested in the site, Whitworth remembers rain pouring through the ceiling during a visit. The senior living space lasted until 1985, when the building was purchased for $3 million by a group of California developers. This group planned to redevelop the structure for $5 million, but that failed, and it closed on January 31, 1987—a little less than five years after it was added to the National Register of Historic Places. In October 1987, the Bibles were forced to buy the building back for $1.97 million, but no actual money exchanged hands. It remained shuttered for more than a decade after that—at least to the paying public. The homeless made it their shelter, and for any teen with half a brain, breaking into the hotel via the Court Street entrance became a rite of passage. There were even rumors of

satanic worship. Inspection crews sometimes found altars covered with dead pigeons and the words "Satan Rules" scrawled on the walls. But mostly, they found empty wine bottles and used crack pipes.

City firefighters knew the spot as well. Arson was sporadic through most of the decade, including three fires on one day in July 1996. Violence was, too, as the railings in the two-story lobby were sometimes used as weapons. By the mid-1990s, the only window not covered in plywood belonged to a real estate and insurance office working out of the building's first floor. The state's chapter of the American Institute of Architects placed it on the list of most endangered historical sites in the Southeast. It also earned the dubious distinction as one of the Top 10 Most Endangered Historic Properties in South Carolina. White said that while city leaders kept focusing on reopening the hotel, there were numerous other offers that got consideration. They included moving part of Greenville Technical College to the site, putting the Governor's School there (instead of overlooking Falls Parks, where it eventually opened) and putting in a Quality Inn hotel on the site.

In 1995, a group from Huntsville, Alabama, known as Greenville Hospitality Associates purchased the site for $1.2 million. It was led by a man named Phil Dotts. Whitworth said that originally Dotts came to the city hoping to finance garage construction but was steered toward purchasing the Poinsett as an incentive to build a garage. One of the keys to the Poinsett project was the rebirth of the surrounding area. While the city redid Court Street Plaza, the hotel spurred numerous private operations. Carolina First Bank's headquarters was located next to the old Poinsett. It had been the site of the old Belk's department store and had been owned by Carolina First Bank since 1993—two years after the Greenville-based bank moved into the old First National Bank Building. With work appearing to be moving ahead on the Poinsett Hotel, Carolina First eventually agreed to move to a new structure next to it called Poinsett Plaza, a 190-foot-tall, ten-story building featuring a 23-foot-tall tire spire. Carolina First's CEO, Mack Whittle, told the *Greenville News* in October 2000 that his team had considered construction for several years but held off because of the dilapidated Poinsett. The two would share the new garage.

Dotts's group's plans called for a 120-room hotel, condos, offices and possibly shops and restaurants for the site. However, Whittle told the *Greenville News* in October 2000 that Dotts was warehousing the site while Whittle shopped for potential developers. At one point, Dotts agreed to raze the building if a developer could not be found. But at the same time, Carolina First was financing

The torn-up Court Square as part of the Poinsett Hotel revitalization. The city was able to completely close Main Street during the work—something that amazed Mayor Knox White more than a decade later. *Courtesy of the City of Greenville.*

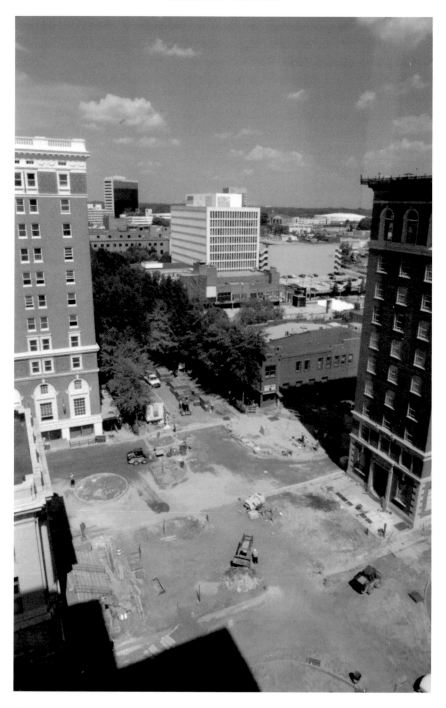

The demolition and grading for Court Square unearthed long-forgotten streetcar rails under Main Street. *Courtesy of the City of Greenville.*

the renovation of the Francis Marion in Charleston. Whittle suggested the idea of loaning money for the Poinsett to Steve Dopp and his business partner, Greg Lenox, and their company, Packwood Development of Charleston, if they restored it next. Dopp, though, tells a slightly different story. He was familiar with Greenville having worked in Charleston, but he didn't know the city. However, he knew Charlene Tucker, a Greenville native whom he and Lenox hired to be the pre-operation sales manager for the Francis Marion in Charleston. She would come in every week and tell Dopp that he needed to do the Poinsett next. Eventually, around 1995, he and Lenox made the four-hour drive up Interstate 26 to Greenville to see the Poinsett. They saw the potential and quickly started making calls.

"We were a little surprised no one had ever called us about the hotel, to be honest. It was the

There were some bad ideas out there for the hotel. The prevailing wisdom was the hotel would never be reopened. It was the dark, hulking building over an abandoned part of Main Street. The LDR report called for the historic structure to be a hotel again. Steve Dopp and Greg Lenox did several hotels. They had just completed the Francis Marion. I knew the city manager was working on the project but wouldn't give me the full story. He really controlled the situation. That is how he worked. Eventually, Steve actually called me at my office and invited me to Charleston. We ate at the Francis Marion, and it was very cordial, but I couldn't quite figure out what he wanted. He then asked why I was not talking to him about the project? I said I didn't know he wanted to talk. He quickly filled me in, and we got excited about saving the Poinsett.

—*Knox White*

same era. The same architect. South Carolina's a small state. No one put it together," he recalled almost eighteen years later while sitting in a small alcove in the Poinsett that he dubbed "Knox's Corner" because of how often the mayor would meet people there.

As business partners, Dopp and Lenox were contrasting. Dopp was the face of the project, the guy who could talk to anyone at any time. A New Jersey native, Dopp grew up around hotels—family trips, and even his wedding were held at historic hotels. It may have been one of the reasons he left the practice of law after just a few years to become a hotel redeveloper. Or, as he put it, he liked everything about the practice of law except having to have clients to survive.

With law not being his thing, and realizing his passion lay in restoration and development of historic properties, he joined forces with Lenox, a street-smart Detroit native who had started in hotel financing in the early 1970s.

After touring the hotel and finally meeting with White, they told him that the Poinsett needed to be secured—even if they weren't going to do the project. Dopp outlined a very succinct hierarchy of what was happening there. Vagrants controlled the basement. The lobby was a shambles of debris. "Professional ladies" and their heavy-handed bosses, as Dopp put it, controlled the second and third floors. According to White and Dopp, Lenox walked in on one woman ready to work, so to speak, and quickly realized this was a not good situation. White remembers Lenox coming into city hall with a look of shock on his face. Dopp said he called the police to make sure things like that didn't happen again. The college kids had control of the roof—if for no other reason than they were the only people inclined to walk up that many flights of stairs. They could drink, relax on lawn chairs and watch the sunset—or maybe the sunrise, depending on the party.

The story that a new group was interested in the hotel first made public light a week before Christmas 1996. That's when it was announced that Packwood of Charleston had signed an option to overhaul the hotel on behalf of Greenville Hospitality Associates. Construction was slated to begin that June, with a grand opening in late 1998.

However, Dopp and Lenox bought the Poinsett for $1.5 million, and in August 1997, Dopp and city officials announced plans for a $15 million renovation; an $8 million, 960-space parking garage; and an office building that would eventually become Poinsett Plaza. Early suggestions called for a late 1999 opening. Those plans also called for a home for the South Carolina Children's Theatre, which never came to pass. City manager Aubrey Watts cautioned that the financing package from the developers was not ready. Whitworth said it was an unusual progression, but unusual progressions are normal for the city. Someone comes to Greenville to do a parking garage, buys a hotel, sells the hotel and ultimately builds the garage, she said.

"That is the kind of thing we do as a city that are outside of the box," she said.

At one time, the hope was to open in June 2000, the seventy-fifth anniversary of the original opening. An underlying hope was that the revitalized hotel would spur the town square with the chamber of commerce and family court buildings coming back to life, and in a few years it would, as Court Square, became one of Greenville's most prominent sections of Main Street. A June 1999 *Greenville News* article quoted McDuffie Nichols of the National Main Street Center as saying, "The project itself, if that were the

only thing being done, it probably wouldn't have as much of an effect. But if it's one of several things, what it typically does is spin off other activities."

The renovations were covered with great interest by the local press, with scores of articles pontificating about the grandeur of the hotel; one even gave out the cherished recipe for spoonbread. And while many hoped for a rebirth, there were doubters galore. In a January 1997 article in the "Lifestyles" section of the *Greenville News*, E. Roy Stone, who ran his real estate/insurance business out of one of the front parts of the building, was pessimistic at best when he said, "I've been reading about it for the last four or five years. This is about the fourth time this thing has been announced." He paused and then added, "But I do hope this goes through."

Even construction was fraught with peril because of the complex financing. Dopp called it a seven-layer cake of financing. White, though, credited Dopp and Lenox for not losing sight of the long-term vision as they constantly juggled pots of money. Work stopped in September 1998 because there was not enough funding to continue on what would become a two-hundred-room hotel that featured eighteen suites. According to the *Greenville News*, Westin Hotel's umbrella owner, Starwood Lodging, backed out of plans to commit $4 million. Dopp told the city immediately, but the issue didn't become public until several weeks later, when the developers applied for a $3 million grant from the state Jobs-Economic Development Authority and a $1 million grant from the Coordinating Council for Economic Development.

But in late September 1999, it looked like Dopp's plans were coming to fruition when 120 local dignitaries came to a formal ribbon cutting in the Joel R. Poinsett Ballroom. Guests got the full treatment—spoonbread from the original recipe and walking the terrazzo floors—even while crews still worked on the interior. It even sparked developer Courtney Shives to remember getting his hair cut in the basement barbershop, the same place where Louis Armstrong is said to have gotten his locks clipped. Dopp told the *Greenville News* that night, "We are finishing it once again to be Carolina's finest hotel." There were other events, as well, to gauge interest and reaction. White recalls Arlene Marcley starting a mini-museum in city hall as something that really sent a message that the renovation was about more than a building. The museum led to a small gathering of former employees of the hotel. White called it "one of the most moving experiences I ever had" because of the love people had for the hotel. Later, a private ceremony for former employees was held inside the hotel. White tells the story of one elderly gentlemen just smiling and saying he felt like he was sixteen years old again being back in the hotel. Everyone seemed to have a memory and wanted to share it:

We got an early indication that it was going to have an emotional effect on people. It would appeal to people's hearts. Arlene put the word out. A call went out to the community—anyone with a souvenir from the hotel for an exibit in city hall. People came out of the woodwork with everything from photographs to menus to silverware to plates. All kinds of great things. It pretty well filled up city hall. It showed the impact the hotel had on the community. There was a lot of lore about the hotel. One of them was the money-cleaning machine. It sort of became a big thing because everyone talked about it, but no one knew where it was. The day the museum opened, someone came forward with the machine, and we were like "aaahhhh" it actually exists.

This was all window dressing to the main event in October 2000, when the doors officially opened. The Poinsett reopened with, of all things, a fundraiser for the Peace Center as work went on to the very end. Dopp explained that he wanted to open the hotel with a bang. While hard hat–wearing employees from Harper Corporation, a local construction

Mayor Knox White addresses the crowd at a party for former Poinsett Hotel workers. *Courtesy of the City of Greenville.*

The cake was a highlight of the party, but White says the discovery of the famed money-washing machine was the icing for the event. *Courtesy of the City of Greenville.*

Mayor Knox White (left) and Steve Dopp (right) address the media and former Poinsett employees. Their shared vision saved Greenville's most famed building. *Courtesy of the City of Greenville.*

Nothing said downtown Greenville was back more than the reopening of the Poinsett. It spoke to the older people in Greenville who were the most skeptical about downtown redevelopment. When the hotel first opened, people came in droves. Greenvillians. Just to walk around and see the hotel. Steve Dopp told his general manager to just let them come and gawk. That shows how powerful a pull the hotel has. I remember looking downtown from my office on a Tuesday and watching a steady stream of people going into the hotel. Come and gawk.

—*Knox White*

company, buzzed in and out of rooms and dust was on the floor, a team of seamstresses was set up in city hall measuring staff for uniforms (ruby and charcoal blazers for the doormen and bellhops) to wear on opening night and beyond. Both the *Greenville News* and the *Greenville Journal* published commemorative sections heading into the grand opening in October 2000.

A few weeks later, the hotel was opened to the public via an open house in November, when residents were allowed to gawk and point at the ballroom; that is, after months of them gawking and pointing at the construction from the outside.

The renovation was something Greenville had never seen. Work included a three-story addition on the back of the building to add twenty-seven rooms. More than three thousand gallons of paints were used, fifteen thousand yards of wall covering hung and $25 million spent during ten thousand hours of work to create a hotel that looked, not new, but like it had never closed. That meant little things like hiring Jim Holloway, a fourth-generation master plasterer, to re-create the work—and that 135 people were working at the apex of renovations. Consider that it cost $1.5 million to originally build the hotel; this shows the work needed. Of course, the original estimate for renovation was $15 million. Dopp, though, said at the time that in some ways the extensive damage to the hotel over the years made the renovation that much easier. "It's very unusual in projects like this to be able to bulldoze the top floors to layer a very modern, efficient and functional building on top of these historic public rooms downstairs." Guest rooms were gutted to just steel girders and then rebuilt to modern standards using old-style flair. The hotel's massive disrepair was both a hindrance and a bonus during the renovation, Dopp said. Since so much of the upper floors were left to rot, it was easier to tear down to the steel girders and start over. And since it had been abandoned for so long, it allowed a certain amount

of dramatic license during the restoration. Most stories about the hotel's revitalization focus on how the grandeur was restored. This is true, but not exactly how it originally was used. Walking around the hotel in just a few minutes, Dopp can point to dozens of particulars that were redone, rebuilt and reorganized. The main entrance to the "Gold Room," one of the feature ballrooms, was built anew, and the old main entrance is mostly forgotten. A balcony for bands was converted into two guest rooms—just enough to get to two hundred rooms. Back-of-the-house areas were converted into meeting rooms and smaller banquet areas. In some ways, it was like an architectural dig as opposed to a renovation project. Dopp kept seeing pictures of an old dining room and couldn't figure out where it was since nothing in the building resembled it. He finally realized the space had been subdivided into a series of smaller meeting rooms with a lower ceiling. It literally had been built over and forgotten. Another find was the old hotel safe, which many people didn't think existed anymore. It was found and converted into a bathroom stall in a first-floor men's room.

Mostly, though, the hotel served as a touch point for redevelopment, something that Dopp believed would happen all along.

"There had been a generation of failure with the hotel. A hotel that size can be a cancer for the surrounding neighborhoods. It drags them down, and a lot of people don't see the potential. It's key to look at the big picture," Dopp said. "If you ignore the initial problems and see what the hotel can do—that's the goal."

Eventually, the rebirth came. Originally, Coffee Underground, Carpenter Brothers and Twigs set up shop in the outer portion of the hotel as a sort of test run for growth. The Poinsett Plaza opened in 1999 with Carolina First as the major tenant. One of the interesting aspects was the top of the build because it was not "flat" like other downtown high-rises. Developer Bob Hughes told the *Greenville Journal* that this was intentional because they "really wanted to make a statement with the top." While early projections of a national chain store or higher-end retail store never came to fruition, the $25 million structure became a major part of the downtown skyline. The opening of Poinsett Plaza was significant because it signified new growth in downtown. White said at the press conference announcing the structure that "the revitalization was considered impossible just two years before." But it signified the important corner that downtown had turned in the first few years of White's term. The relatively small two-block section of downtown saw almost $65 million in investment in a relatively short amount of time; this also included the creation of the Downtown Baptist Condos

for $5 million, Mark Kent's renovation of Court Square for $3 million, Harper Construction updating its building for $500,000 and Erwin Penland pumping in almost $3 million for its structures.

In June 2001, the Palmetto Trust for Historic Preservation labeled the renovation a banner success story. By November of that year, the hotel was routinely exceeding 75 percent occupancy and being ranked in the top for service of all Westin properties. It was being featured in magazines ranging from *Carolina Living* to Southwest Airline's *Spirit* magazine to *Martha Stewart's Weddings*. In 2003, the revitalized hotel was given a four-diamond rating by AAA. It has since regained its glory as the likes of Lance Armstrong, Sheryl Crow and George Clooney have spent the night at the renovated hotel (though not at the same time). It has hosted numerous politicians and served as the de facto headquarters for the 2004 Democratic Presidential Primary as candidates trucked back from the Peace Center to the hotel to meet the press following a televised debate.

And in 2006, the famed red-letter sign on the top of the hotel was relit, much to White's delight. Restoring the sign had been in Dopp's initial plans and vision, but money prevented it from happening. It was an understood compromise, but one about which White often kidded Dopp for several years. The joke was the hotel renovation wouldn't be complete without the sign. Work crews managed to take down the sign without White noticing at first, but it soon caught his eagle eye, and he called Dopp, who confirmed what was happening.

"That was a great moment. That was the final piece we needed," White said. "We had a rooftop ceremony to turn on the sign. That was Steve's little gift to me."

Dopp said he has restored about fifteen hotels over the years, and while others have been more lucrative, the Poinsett may have had the largest cultural impact because of how it helped bring back a generation of people to downtown Greenville. "This hotel meant the most to its community," he said.

Looking back a decade after the grand opening, White said the lesson learned from the Poinsett was knowing when to save a piece of history and when to let it go. Saving the Poinsett was key to so much further growth of Greenville. It not only transformed but also helped restore faith in city hall. People began to realize that redevelopment and historic preservation could happen, and it didn't just mean bulldoze and build modern. Now, when White goes into his office on the tenth floor of city hall, the Poinsett is a reminder of what happens when government seeks outside help and looks long term instead of short term.

Chapter 5
New Directions

The Peace Center and the Poinsett Hotel projects served as near-perfect bookends for downtown development in the 1990s. In the Peace Center, Greenville had another anchor downtown, and it was an anchor that was bringing people to Main Street. The Poinsett helped make Greenville more walkable because there was no longer a visual barrier slicing Main Street in two.

This was the continuation of creating major anchors downtown that started in 1982 with the Hyatt, but unlike in the 1980s, downtown development did not falter in the new decade.

"I think the Hyatt was so bold, and it began to get us thinking that it's alright to swing for the fences. It was probably a mistake that the next big thing was the Peace Center. It was too far away. It slowed us down," said Bob Hughes, one of Greenville's key development leaders.

The 1990s did not lose steam thanks to some major changes and projects that helped change downtown and put it on the path toward greatness. They ranged from ideas as simple as sticking to the LDR plan to the construction of the Bi-Lo Center to a series of entrepreneurs helping to create a sense of nightlife downtown. That was the beginning of a coalescing of ideas, said Nancy Whitworth, the city's economic development director. The city was going to take more active control in making sure development occurred.

"There was a realization in the early 1990s. Up until that point, we didn't really have a clear focus on the holistic approach as to what we

needed to be doing in economic development. You can't abdicate a lot of that. We had to step in and accept responsibility. The mayor, council and manager at the time saw we had ten years under our belt and started this and got it rolling. It became about keeping focused on the fundamentals and keeping engaged. That is when we began to look at what's next," Whitworth said.

The early 1990s saw a new wave of growth and visions for downtown Greenville. The Greenville Chamber formed a series of groups that looked at development and growth in various sections of the county, including one called the Downtown Area Council. During the course of the decade, this group would be instrumental in leading the way for many of the things that helped shape modern downtown, such as noise ordinances, police officers patrolling downtown, encroachment rules that allowed people to drink beer or wine in a cup outside a building, Sunday alcohol sales and banners on street posts. Jay Spivey was one of the leaders of this group, which consisted of building owners, restaurant/bar owners and a handful of merchants.

"There were a lot of people trying to dream up new ideas. It was hugely fun to be involved in," Spivey said. "It was the start of an era. All of a sudden, it went from the city acting alone to the dawn of a lot of public-private partnerships."

Now the publisher of an e-magazine about Greenville called *Fete*, Spivey was then the owner of Henni's, a bar on Bergamo Plaza. When it opened in 1992, it was only the fourth bar in downtown that was open past nine o'clock and had a then unheard-of selection of ninety beers in stock. A Greenville native, Spivey took a chance on downtown because he saw something that wasn't there—such as a bar that offered acoustic music, as well as buckets and tubs filled with ice-cold beer. The early 1990s saw the first major growth in Greenville's nightlife, including the explosion of events such as Main Street Fridays, which literally doubled in attendance several years in a row.

"There was a lot of trial and error, but the city was trying to benefit small business owners," Spivey said.

With the aid of the Peace Center's schedule, other things began to bring people downtown in the mid-1990s, including Downtown Alive, a popular post-work party on Thursday nights on Piazza Bergamo. This was an Italian-style plaza in front of the Bank of America tower on what used to be open roadway. It was an early gathering spot for young Greenvillians, including Carl Sobocinski.

A Clemson graduate working in real estate, it was during a Downtown Alive event that Sobocinski went with a friend to the old Elks Lodge on East

North Street, about a block from Main Street. His friend had purchased the building because it was downtown. He had no real plans, but Sobocinski saw potential when he walked onto the second floor, which was where the Elks' dining hall had been.

"The wheels started turning," he said.

The real heroes of downtown's revitalization are the people who have invested and brought the wonderful mix of business to Main Street, especially the restaurants, bars and coffeehouses. We would not have been able to attract residents and meet our goals of creating the magic of a mixed-use environment without the creation of an amazing hospitality scene. Carl Sobocinski set out not just to make his own restaurant successful but to make downtown Greenville itself a premier food and entertainment venue. Now, he, Rick Erwin and so many others share the same larger vision. In so many ways, they now define our Main Street and provide the backdrop for all we do.

By the time the LDR report was being completed and showing Greenville's Main Street failings, the rest of the world was taking notice and was amazed by the transformation to date. White went to Washington, D.C., in 1997 as part of a group of mayors asked to essentially explain to Washington, D.C. leaders how to make a better city. His main suggestions came straight from the Greenville handbook: more street festivals, a tree-lined downtown, a greater voice for residents in what happens in their neighborhoods and a commitment by the public sector to work with its private counterparts. To put what White and Greenville were doing in perspective, the other mayors invited were from Philadelphia, San Diego, Indianapolis and Chicago.

In 1995, Harvard School of Business's Rosabeth Moss Kanter wrote her seminal book, *World Class: Thriving Locally in the Global Economy*, which featured large sections on how Greenville and its downtown had revitalized. The book focused heavily on the global investment in the Upstate—especially BMW—but it also shed a glowing light on what was happening in downtown Greenville. In November of that year, Kanter was interviewed on PBS's *Newshour* by David Gergen, editor-at-large of the *U.S. News & World Report*. During the lengthy interview, Gergen said, "I remember as a child going to Greenville-Spartanburg, and it was an area of very blue collar and small town, and it seemed very much the old traditional South Carolina. Going back there today, it's absolutely

Greenville's downtown skyline on a chamber of commerce–type day. *Courtesy of John Boyanoski archives.*

remarkable. What struck me about your book was the degree of local leadership in the private sector."

One of the biggest events in the 1990s was the opening of the Bi-Lo Center in 1998. Seated at the foot of I-385, it gives drivers their first true view of what downtown could be a few blocks ahead. In addition to the region's largest entertainment draw, the construction of the Bi-Lo Center checked off the list one of the region's longtime hopes: a downtown "coliseum." Efforts to fund a coliseum with tax dollars failed three times between 1973 and 1990, leading many people to doubt whether this area would have an entertainment arena to match the obvious need for one. But in the mid-1990s, a group called ScheerGame, led by former NBA Charlotte Hornets' officials Reggie Williams and Carl Scheer, came up with a plan that would finally build the arena without raising tax money or using property tax—something that was and remains a big no-no for residents.

He first pitched the idea in 1992 after attending an Atlantic Coast Conference baseball tournament here, where he became aware of the city's untapped potential for sports entertainment, but it would be almost four years before ground was broken for the sixteen-thousand-seat arena. The

reason was the funding and ScheerGame's tenacity. The deal took a long time to put together because of the community's reluctance to put money into it even though Mayor Bill Workman was a major proponent. However, where others had stopped pushing, ScheerGame eventually came up with a plan that would fund the project. The arena was built from four bonds taken out in the late 1990s. Two of the bonds were to be repaid from tax money for the old Memorial Auditorium, which already were on the books. Naming rights for the Upstate's homegrown supermarket chain paid the third. The fourth is paid from proceeds of concerts, sports events, circuses and anything else that can draw a buck to the $63 million white-domed structure placed at the foot of the main artery into downtown. It was one of the most inventive financing deals in arena history, according to the *Sports Business Journal.*

The arena opened with a sold-out Janet Jackson concert in September 1998, followed the next night by a sold-out show by Pearl Jam. In the ensuing years, the musical acts have mainly centered on reunions of 1970s and 1980s rock legends, including The Who, the Eagles, Elton John, Tina Turner, Cher and Rod Stewart, mixed with a heavy dose of contemporary country stars such as Shania Twain, Kenny Chesney and Tim McGraw, along with circuses, gospel revivals, political rallies, motocross and monster truck shows. It also has brought some notoriety, both good and bad. Protestors railed on the arena board and managers for scheduling a 1999 Black Sabbath show on a Sunday. The Bi-Lo Center was the first place the Dixie Chicks played following their fall from country music grace for maligning then president George W. Bush. The center hosted a wildly successful Bassmaster Classic and an even more successful first two rounds of the 2002 NCAA Tournament. Pro sports have a spotty record, as minor-league football and basketball teams have struggled to find fan bases, but hockey franchises have done well.

A 2003 editorial in the *Greenville News* marking the arena's fifth anniversary summed up many of the Bi-Lo Center's attributes for the growth of downtown:

> *Greenville ushered in a new era with the opening of its new arena that has lived up to all the promises of providing top-name entertainment. What the Bi-Lo Center also has done is accomplish this without expecting, or needing, an infusion of public money for operating purposes. That it has is simply outstanding, especially when one considers the challenges presented by a lingering recession. Five years ago, the doors swung open on the Greenville area's new Bi-Lo Center, the long-awaited and highly debated sports and entertainment arena that had been a dream, at least for*

many people, for about three decades. The Bi-Lo Center's fifth anniversary provides an appropriate occasion to celebrate its hard-won success and to reflect on the can-do spirit that has allowed Greenville to reach some seemingly unreachable goals.

Almost in conjunction with the Bi-Lo Center was a new emphasis on tourism, something almost unheard of for Greenville and the Upstate. The idea of vacationing in South Carolina meant the beach and the coastal towns for generations. The idea of people coming to the Upstate—let alone to Greenville—was almost unheard of, but a vision started to come together in the late 1990s. It was born out of the idea that Greenville could become a hub for business tourism. Chris Stone came to Greenville in 1996 to head up the Convention and Visitors' Bureau. He saw potential but said there were a lot of challenges. The region had amenities, but not many of them were downtown.

"I distinctly remember it being a challenge when friends and family came to town. If they needed something to do, we sent them to Biltmore. If they had kids, we sent them to Charlotte and Discovery Place. If they wanted a Southern experience, we had to take them to Charleston. If they needed a fancy meal or fancy shopping, we had to go to Atlanta. It was almost kind of an embarrassment. Also, if you saw someone with a camera around their neck, you would have laughed. What would they be shooting?" Stone remembered.

Stone had been working in Washington, D.C., and admits he had never heard of Greenville when he was contacted by a headhunter. However, he was intrigued by the potential and applied for the job but adds he never thought things would have taken off so quickly.

"I believed I would be here for a period of time. I was looking at this as a four- to six-year window. I saw the potential with the falls. I saw opportunity. But I didn't overthink any of it. I didn't think anything major would happen in that time. What I thought I could do was to help put the organization in the right position and then move on," he said.

However, a lot of the things that started occurring in the late 1990s, such as the creation of the Bi-Lo Center, a focus on public art and more restaurants, began to change those perceptions. It's to the point now that people with cameras are commonplace.

"Fast-forward fifteen years; do we have to send anyone out of town? Certainly not," Stone said.

This period of time also started producing the first major influx of housing downtown, especially in the Main Street area. Again, housing had been a

The condos at Downtown Baptist were the first sign that residential could be done in mass quantities downtown. *Courtesy of John Boyanoski archives.*

Poinsett Corners was built on an underused parking lot owned by the city. It was one of the first developments to succesfully shift growth away from Main Street. *Courtesy of John Boyanoski archives.*

key part of downtown planning since the early 1980s, when Bainbridge and GCAP were pushing it, but it had been slow, as many of the larger area developers were content to work the suburbs and were convinced there was no land downtown on which to build. White tells a story of gathering a group of developers in his city hall office to pitch the idea of downtown. One of them fell asleep, but the seeds were planted. One of the first major projects to gain attention was when Downtown Baptist Church sold thirty-seven condo units in the back of its downtown space at auction in October 1999. The story in the next day's *Greenville News* showed rows and rows of people holding auction signs. To White, it was a sign that people were wanting to live downtown and that all of the work such as the Poinsett restoration, the Peace Center and the Bi-Lo Center were paying off:

> *In the mid-1990s, people still didn't see the possibilities of a residential downtown—especially the bigger developers. The breakthrough moment came with the sales of the condos at old First Baptist Church. It made front-page news that people came in droves for the auction of the units. Thereafter, the development community woke up to the opportunity that was before it. We then made city-owned sales available starting with a parking lot next to Springwood Cemetery and then a lot behind city hall. Our only condition for them was that any development had to be mixed use and include residential. It was a strategy of being proactive about housing instead of waiting for people to come to us. The strategy worked.*

The next few years brought a string of condo and apartment complexes, including 400 North Main, which featured thirty-eight units on a little less than an acre of land near Springwood Cemetery on Main Street; Poinsett Corners, seventy-four units built on a seldom-used city parking lot; a string of apartment/condos at what was first known as Wachovia Place and is now Wells Fargo Place on Main Street; fifteen town homes on Butler Avenue near the Greenville County Library; McBee Station, just three blocks from Main Street, with close to two hundred units; and many more projects throughout the urban core. People began coveting being downtown; even "near downtown" became a selling point. For generations, retail ads had quoted a house or apartment's proximity to the interstate, the malls or schools. In the early 2000s, the phrase "minutes from downtown" became part of the real estate lexicon. White said downtown residents are a blessing for numerous reasons besides just being bodies on the street and helping the taxpayers. They are another set of eyes and ears

that spot problems quickly. They are the ones who call city hall if a light isn't working or if a bar might be breaking the noise ordinance. They are an integral part of the fabric of downtown.

Whitworth said the mid-1990s to the mid-2000s was a key juncture. Greenville's downtown came to life in a way that finally met expectations laid out back in the 1970s. Even when there were failures, Greenville's leader learned from then forged ahead.

> We made residential a priority and implemented a strategy to attract developer interest. By ensuring that downtown was clean and safe with emerging entertainment and dining options, people began to see it as a place to live and not just visit. This was a big transition that happened around 2000.
>
> —*Knox White*

"There is a ten-year span in the 1990s until the early 2000s where we had done some things that really changed Greenville," Whitworth said. "We kept with it. The feeling was maybe the timing's not right now, but it will be. That was in the 1990s. Now, if you look now, it was a no-brainer. I really commend the mayor and council."

Hughes compared the success to compound interest: "It's sustained effort that is above average. If you do 2 percent over the rest over and over, suddenly you get this great acceleration."

Chapter 6
Shopping Spree

One of the toughest nuggets for Greenville to crack in terms of its downtown revitalization was retail. By the time White took office in 1995, downtown retail was a mixed bag. There were some longtime stores such as Ayers Leathers, Sedran's Furs, Rush Wilson, the Greenville Army Store and Drake's Flower Shop mixed with newer shops such as Llyn Strong Fine Jewelry that offered specialty retail, along with an odd assortment of consignment shops, wig stores and hip-hop clothing stores. They all had customer bases, but downtown was hardly a place you shopped for something on a whim. It was a far cry from the days when Ivey's, J.C. Penney's and other big-box retailers lined Main Street.

Mayor White recalls:

> *Retail took awhile. The city was still pretty desperate. A lot of false starts. We still had the attitude that we were so desperate that anything was OK. If you could bring really any business downtown, we would take it. That was "success." That was kind of the attitude. I kind of bristled at that.*

Greenville's road to getting and retaining retail started with a lawsuit, one of the nastiest in city history. One Main Place was a two-story, thirty-seven-thousand-square-foot building that formerly housed Meyers-Arnold in downtown Greenville. Located just off Bergamo Plaza, it was purchased by the city in the mid-1980s with the hopes of eventually being the cornerstone of downtown redevelopment. The Greenville Central Area Partnership was

headquartered there for a while, and Bob Bainbridge remembers redoing the floors over one long weekend. He even coined the name One Main Place. Yet it lingered for years as an underused space as projects such as an indoor mall and small art gallery space did little to spark interest. That is, until the mid-1990s. By that time, restaurants and bars had proven that Greenville was on the road to somewhere better than where it had been. "It was like the Poinsett, a big vacant building in the middle of Main Street. It's hard to imagine that now," White said.

In July 1995, the first steps in what was hoped to be a new future were taken when the city sold One Main Place to a group called Professional Office Rentals, $325,000, but with the stipulation that prevented "taverns, bars or nightclubs" while giving city manager Aubrey Watts power to protect the city's interest in the matter while helping promote a sale. "The guys who owned the building. They had bought it from the city. Took it off our hands. In part of the deal, we had an agreement to make retail there. A lot of people were very suspicious of this. Great suspicion. Their suspicions would be confirmed," White said. Publically, nothing happened for almost two years, but behind the scenes, something was cooking. A large restaurant chain became interested in the site. Then known as Jillian's and advertised as an upscale entertainment and billiards mecca, the chain saw Greenville as its next big location and had already committed to the Charlotte region about ninety miles up Interstate 85.

The sticking point was the clause for One Main Place that didn't allow taverns or nightclubs. There was no way around it unless a waiver was given. And that sparked the controversy. The developers were granted a waiver in August 1997, signed by five city council members and the city manager that cleared the way for One Main to be leased to an entertainment business: Jillian's. The actual signings happened three days apart and, when discovered, touched off a firestorm. White, who did not sign and was out of town when it happened, told the *Greenville News* that the deal was not right and public approval was needed. White said that when he returned, he was asked by Watts to sign the waiver but refused. "I was disappointed to see other signatures on that document," White said. The city, in a later lawsuit, contended that the waiver was void because it wasn't signed at an open city council meeting. The city would also oppose Jillian's by saying it ran counter to its development plans for the downtown. However, in October 1997, Jillian's and the One Main Place developer signed an agreement for an establishment featuring billiards, live music, deejays and coin-operated gaming machines (aka video poker), which were then a statewide

controversial hot topic. "It was one of the biggest explosions I had ever seen. People were irate at city hall," White said.

It soon was announced that Jillian's was going to spend more than $2 million in renovations for an April opening but would hold off on video poker for one year. That was not enough for some downtown business owners, who faxed a letter to White the day before Thanksgiving accusing the city of empty promises in regards to downtown retail. Forty had grown to five hundred by early December. That was the number of people who signed a petition against Jillian's moving to One Main Place and calling for city council to rescind the August vote. At the time, White publically said he wanted a revote as well, telling the *Greenville News* that the "heart and soul of downtown was at stake" and it was "important to build trust between the community and city council." That led to a December 15 council meeting where White, Garry Coulter, Ray Martin and Lillian Brock Flemming voted to revoke the permit for Jillian's in front of a packed council chamber. Coulter had been elected since the initial vote and proceeded to be the swing vote.

That was not the end—not by a long shot. Over a period of almost three years, things got ugly. The developers sued the city. The city countersued. An attorney called the city buffoons. City council members were deposed in front of the media. The two sides settled for $2.1 million. Jillian's asked to be compensated for damages. The city said no. Jillian's sued the city and the developers. The case, though, ended in December 2001. According to court documents, the case had been settled and, under the dismissal, cannot be filed again. Terms of the settlement were not disclosed, but no city funds were expended. Almost immediately, rumors surfaced that a "unique merchandise store" was looking at One Main Place. White recalled an interesting time.

So then what? We were back to where we started. The city owned a big empty building. Back to square one. Our acting city manager had been up in Hendersonville and been to the Mast General Store. I came to my office one day and on my chair was a Mast General Store brochure and a card that said John Cooper, president. She said, "I went up there and it's a great all-purpose general store. It would be perfect for One Main Place. Check it out." A few weekends later, I went up to Hendersonville to the Mast General store. It was love at first sight. I thought, this is it. This is great. I came back and did a cold call to Mr. John Cooper, and he was kind enough to take my call, surprisingly enough. I told him about One Main Place and how it would make a perfect Mast General store. He said, "Thank you, I appreciate the conversation. At this time, we are in the process of opening a

*store in Asheville. Let us finish that. Digest it, and I'll keep you in mind."
I thought that was nice but didn't expect anything. Well, lo and behold, two
years later, at a random time, the phone rings, and it's John Cooper.*

He wanted to know if White remembered their last call and, more
importantly, whether the space was still available. Cooper came to town
a few weeks later, and White said he looked like perfect Hollywood-type
casting for what the president of Mast General should be—complete with
cowboy boots, a flannel shirt and blue jeans. White remembers:

*We had taken many people over the years into that building. It was vacant.
It was cold. We opened the doors, and we walked inside. He walks inside
with his cowboy boots and blue jeans. He stopped and said, "Do you
remember what you told me on that first phone call? You said this would
be the perfect Mast General Store." He walked past me. I remember the
creaking floor, and he said, "You're right. This would be the perfect Mast
General Store."*

The deal was quickly done. "It was exactly what we wanted," White said.
And Greenville began to take a crash course on all things Mast General.
This was the same Mast General about which CBS's Charles Kuralt once
pontificated, "Where should I send you to know the soul of the South?
I think I'll send you to the Mast General Store." It was a fairly accurate
statement considering the wares sold at Mast General. Burt's Bees Beeswax
Hand Creme. Radio Flyer wagons. Long underwear. Birdhouses. Hiking
boots. Wool shirts. Hats. Sweaters. Watches. Butter rum candy sticks. Giant
jawbreakers. Chocolate-covered peanuts. Blankets. Rugs. Hammocks. Mast
General was the South in a way few outside of the South could understand.
This was not moonlight and magnolias. This was farmers and millworkers
who cared for a more genteel life. Founded in a tiny North Carolina town
outside Boone called Valle Crucis, Mast General was nothing more than a
general store and local post office from its inception in 1883 to its closing in
1977. Three years later, John and Faye Cooper bought the building and the
name. Originally looking to create a catalogue company in the vein of being
the L.L. Bean of the South, the couple realized there was something more
and decided to stick with the general store concept.

The Greenville store marked a major jump for the company, as the
previous five stores in the chain had all been in North Carolina and in
towns much smaller than Greenville. The beauty of Mast General stores is

that the only thing they have in common are a logo and some merchandise. Each store takes on the feel of its hometown, and each store has a different layout. City leaders hoped that Mast General could help make downtown more of a destination for shoppers. A *Greenville News* editorial wrote that "retail is a widely recognized weakness in a downtown that has been successfully reinvented as a center of business and entertainment. And the city, most vocally Mayor Knox White, steadfastly maintained that One Main Place could provide a significant retail presence in one of the most prime locations downtown."

The store opened officially in March 2003 and almost immediately became a success. At a pre-opening reception, White called it the "future of retail in downtown Greenville." According to the a story in the *Greenville News* the next day, "Bringing more retail to the downtown area is necessary, as the mayor said and consultants have pointed out, to sustain other activities in the area. Greenville has a dynamic and enjoyable downtown, and a store such as Mast General adds to the area's vitality and appeal." Mast General became a place that attracted shoppers to downtown Main Street. It gets flooded by people on the weekends, and people carrying small brown bags with the distinctive green Mast logo on the side are familiar sights downtown. Mast General quickly brought some new insights and business to downtown. A super-hip toy store, O.P. Taylors, opened next door in May 2003 and has been one of the most successful shops on Main Street for a decade. White said those stores were connected, as Cooper told O.P. Taylor's owner, John Taylor, about Greenville. "It was wonderful happenstance that it was right next to Mast," White said.

While not exactly an overnight turn for the fortunes of retail, little clusters of stores began to pop up, mainly due to Mast General's success. The West End, which had struggled for years to catch up to the rest of the downtown, exploded in the 2000s with retail egged on by developments such as RiverPlace. Shoe stores. Women's clothing stores. Gift shops. Bead makers. Pet supply stores. Clothiers. All opened and thrived for most of the 2000s. That has led to even more interesting projects, such as a CVS opening at the corner of Main and McBee Avenue—answering a longtime call for a pharmacy/convenience store in the urban core. Publix became a major downtown tenant. In 2012, it was announced that the high-end women's store Anthropologie was coming to the One complex, and it opened in a five-thousand-square-foot space in March 2013. Brooks Brothers announced it would be coming in 2013.

Jay Spivey, publisher of *Fete*, a magazine that covers downtown Greenville life, said retail remains a fragile part of Greenville's growth. It is definitely

stronger than it was in the 1990s, when a lot of retail appeared to be more of an anything-on-the-wall-type strategy.

"It is a lot more legitimate," Spivey said.

During the early 2000s, many people wondered, clamored and discussed the things that Greenville needed in terms of retail. These wish lists often included hopes for major chain retailers, à la Gap and Barnes & Nobles, in much the way Charleston's King Street was laid out. However, in 2006–7, a consulting firm hired by the city during a planning process said that retailers like that would not head downtown because the area was too close to commercial districts such as Woodruff and Haywood Roads. The mass of cars and people were there, not downtown. However, as of 2013, several large retailers have announced that they will be coming downtown, including Brooks Brothers and Anthropologie. Publix has set up shop. Even Walmart has made inquiries in the general downtown area.

White said that it's interesting to see how Greenville's retail emergence started and how it has affected other cities. Mast General came to Greenville with some trepidation. The store had never been located outside the North Carolina mountains. But based on the success in Greenville, it has since expanded to Columbia and Knoxville, Tennessee. Just like in Greenville, both of those stores have sparked economic development rebounds. According to White:

> A lot of downtowns struggle to restore retail to their Main Streets. Thankfully, Greenville didn't go the way of so many American cities that turned their Main Streets into malls. They were trying to beat the malls by becoming them. It was a disastrous decision in places such as Raleigh and Spartanburg. We found a better way to be pedestrian friendly and give retail a chance. Mast General showed that we could attract retail back to Main Street. It wasn't easy, and we had to recruit, but it sent a message to those who doubted that a large retailer could thrive on Main Street.

Chapter 7
A River Runs Through It

There was a time in Greenville's past when comparing someone to the Reedy River was an insult. Seriously. If someone said you smelled like the Reedy, then it meant you were bad news. It was the "Rainbow Reedy" because of the myriad of textile dyes floating down it. Because of pollution from textile plants, not only did the river look bad, but it smelled worse. Another common phrase in Greenville was that the Reedy was the river the nose knew.

Of course, this was decades before the Reedy River Falls, Falls Park and the Liberty Bridge became one of the major, if not *the* major, focal points of downtown. Before the bridge became a symbol of everything downtown Greenville. Before it became the hallmark of revitalization. No, for about forty years, the falls were a hidden part of downtown, lost underneath a large four-lane bridge built at a time when commerce ruled over historical reason. It was born of the same thinking that led to dozens of historic buildings meeting their fates at the end of demolition balls. Greenville was a business town for most of the twentieth century; a downtown with little time when sentiment came into the picture. It was no surprise that there was little outcry when city and state leaders erected the Camperdown Bridge across Reedy River Falls in October 1960. No one cared. Well, not everyone. Some people made several desperate pleas to city council during this time period not to hide the forty-foot falls. They reasoned that the falls were Greenville's birthplace and needed to be appreciated. While their pleas fells on deaf ears at the government level, the Carolina Foothills Garden Club would take up the call.

The garden club was formed in 1938 simply to help women learn about floral arrangements and how to plant around the house. It quickly became a force to be reckoned with as the women spearheaded victory gardens and can drives during World War II, planting and maintenance of plants at Burgiss Glenn, planting dogwood trees throughout the city and joining the Garden Clubs of America in 1952. All are worthy accomplishments, but the revitalization of the Reedy River Falls is the group's grand legacy in Greenville. In 1967, the women began weeding the park area. Harriett Wyche, the president of the organization, called the falls area "an oasis in the heart of the city" and referred to the bridge as the "concrete monster."

The group dubbed its efforts the Reedy River Falls Project and, with the help of the city, acquired roughly six acres of land around the falls from Furman University and several other landowners. The group acquired a cottage near the falls that dated back to the 1920s in an effort to preserve it.

Their work was noticed but not really given much heed by the general population. People didn't understand what these woman saw down there. The Greenville newspapers would throw a story in the lifestyle section once in a while every few years, but that is where the story remained for some time in the 1970s and 1980s. The women were working in an area that no one knew or cared about. If downtown was a blighted area, then the West End, where the falls was situated, was practically the Black Hole of Calcutta in perception and reality. The West End has long been the warehouse district for Greenville. It's a funny little area since technically it's the southern side of Main Street, not the west side. For most of the 1980s, the West End was somewhat of an afterthought in the revitalization efforts. While city leaders created a plan to revitalize Main Street, the general realization was that the West End would have to be completely rethought and revamped. Not an easy task. This was the place you drove through, for the most part, to get somewhere else. Except for the famed Greenville Army Store, located at the corner of Main and Camperdown, there was no real reason to stop in the West End. Unless it was at night and cheap drugs and cheaper prostitutes were on the menu. "In the 1980s, there was this effort to clean up the West End. Demolish buildings. That is why you see so many vacant lots. It is so incredibly sad. Fortunately, we backed off from that or we wouldn't have any stock left. But the question was: why would you want to do redo the West End? There's nothing but derelicts and dilapidated buildings. Why would we waste time on that? My thing was, just wait. It does pay to have some patience," said Nancy Whitworth, city economic development director.

It was a hidden area of downtown Greenville and would remain that way well into the early 2000s, even as the rest of downtown flourished. Yes, there were some wins here and there. The $7.5 million renovation of the West End Market in the mid- to late 1990s brought retail life to the area. The opening of the Governor's School for the Arts brought a new level awareness to the falls and the West End, but for the most part this section of downtown lagged behind. Yet it had the biggest calling card in Greenville downtown's deck for redevelopment. It had the falls—a scenic, one-of-a-kind attraction; the kind of thing that LDR said gave the city personality.

The fact is, as much as the retaking of the Reedy River meant to Greenville from a cultural and economic standpoint for redevelopment, its cornerstone and benchmark would ultimately be the success of the West End. Basically, if the river and the falls remained a blight, the West End would be a blight, and growth would head north at best or just stagnate around a few blocks near the Hyatt. Greenville's great story would be more gristle than steak.

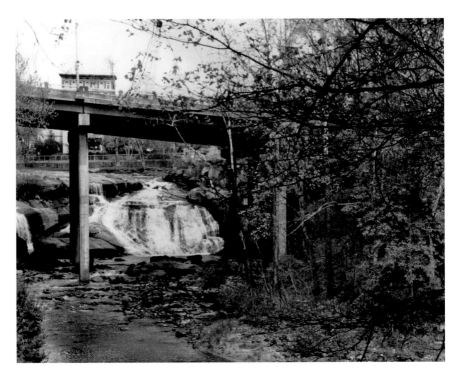

Built in 1960, when people no longer cared for Reedy River Falls, the Camperdown Bridge was a useful part of the Greenville infrastructure. The battle over its demolition split Greenville for most of the 1990s. *Courtesy of the City of Greenville.*

The falls area was Greenville's birthplace and its main attraction for generations. It was a point of civic pride as people ate picnics there, and it was even a tourism destination. There was a giant rock near the base of the falls where people visiting Greenville would chisel their names. The falls were Greenville. That was the feeling at least until the 1950s, when pollution made it an unpleasant part of downtown. In some ways, the abandonment of the falls foreshadowed the decline of downtown a generation later. Building a pedestrian bridge over the falls was not considered a big deal. In fact, it was seen as a good idea because it was going to stir economic development and alleviate traffic, according to planners. The bridge was built in 1959 as part of a county series of bridges aimed at improving Greenville's transportation infrastructure. In addition, the Citizen's and Southern National Bank was locating its headquarters at the falls, and its powerful leadership lobbied hard for the Camperdown Bridge to be added to the system. It was officially dedicated in October 1960, with more than two hundred people watching the ribbon cutting, and the falls would slide into oblivion in the minds of the majority of Greenville residents.

Almost four hundred feet long and four lanes wide with parking, it was a big bridge—a bridge that hid the falls from sight and mind. It would stay like that for almost twenty years, until the work of the Carolina Foothills Garden Club began to resonate with some of the burgeoning efforts to revitalize downtown. The spark for the work had been when scores of more than one-hundred-year-old trees were cut down to make way for a new shopping center on the old Furman campus near the falls. It was the wake-up call that the group needed to do something to preserve the area. An idea was starting to take root. The Carolina Foothills Garden Club even created a master plan for the twenty-six-acre park as a way to show people what they were missing. Greenville had a hidden treasure downtown that was covered by concrete and cinderblock. The Carolina Foothills Garden Club created brochures that highlighted the historic aspects of the park for walking tours. The bridge didn't just obscure the falls; its enormous concrete bases were in the falls. Even if the park were restored, which was happening, the falls were essentially a non-starter for anything truly grand because of the bridge.

The Greenville Central Area Partnership (GCAP) would be the first business entity to publicly challenge the belief that the park was more than just a part of downtown to be avoided. The group funded a 1989 study to look at the park and put it down concisely in words before anyone ever really gave it that much thought: "The Reedy River basin and the falls are a priceless asset for the city of Greenville and, potentially, its single most

important attraction." GCAP's 1989 study was a massive undertaking, but the point was clear. The Camperdown Bridge needed to come down. It blocked views of the majestic falls, the birthplace of Greenville. It divided the area. It made any potential growth moot. The Greenville Central Area Partnership was created to help strategize and fund economic development in downtown. It was boldly putting the idea of demolishing the bridge out there. And the idea gained some traction.

A *Greenville News* editorial from February 1989 bluntly called the bridge "one gigantic concrete and steel eyesore" that needed to come down to help spark new development that was believed to be coming from the creation of the Peace Center. Not surprisingly, the idea was not met with a lot of support from city hall. The reason was that the Camperdown Bridge was a state-owned, four-lane monolith. Mayor Bill Workman told the *Greenville News* in January 1990 that "we're going to look like the biggest idiots taking the bridge down." According to state reports, the bridge would be structurally sound until at least 2040. Workman cited costs in excess of millions, along with the need for the road, as a key example. Workman wasn't alone in his stance. Councilman Dayton Walker was quoted in August 1989 as saying that he was against removing a good bridge. Councilman Ralph Anderson said in the *Greenville News* article that it was the "craziest thing" to tear down the bridge. The only council member at the time besides White to show vision was Jim Miles, who said it needed to be torn down.

The bridge even split families. Esteemed attorney Tommy Wyche, who had helped push for the bridge in the 1950s, said he was ambivalent. His son, Brad, another esteemed attorney and later founder of the environmental group Upstate Forever, told the *Greenville News* in July 1989 that the bridge needed to come down. It should be noted that it was Harriet Wyche, Tommy's wife and Brad's mother, who had been one of the leaders pushing for the Carolina Foothills Garden Club to start planting the park. But the tide to keep the bridge was turning. People started to see the falls as something other than a place for the homeless and derelicts. They saw it like the Greenville Central Area Partnership saw it. They saw it like the garden club saw it—as a place of pride ready to be picked, even if ten thousand motorists a day used the bridge. Even Workman, who had opposed it several times, said discussions needed to be kept open.

A February 1990 feasibility study done by Post Buckley, Schuh & Jernigan, Inc., rammed the point home on how much it would cost in dollars and political capital to remove the bridge. Its surveys showed that Camperdown was a cut-through; over 71 percent of drivers weren't starting or ending

their trips downtown. The study found that the bridge was an important and integral part of the region's transportation network, but there was sufficient roadway capacity to handle the traffic if the bridge were removed. The study then went on to say that the cost to motorists would be $2.5 million in added fuel over a twenty-five-year period. The savings to them by keeping the bridge were equivalent to building a new bridge. The study ends with the warning that removing the bridge was not a "viable option." White says:

> *The early efforts to remove the bridge were met mostly with scorn and even ridicule. A city-sponsored traffic study predicted chaos if it were removed. It warned that the city would have to spend millions to detour traffic around the bridge. These findings were ridiculous then, even more so in retrospect, but they scotched any further consideration of the bridge's removal for several years. In fact, city planning documents call the bridge's removal "no longer valid," meaning it wasn't supposed to be discussed. That would change.*

A little more than a year later, though, sentiment was changing. In April 1991, an independent task force recommended removing the bridge. The eleven-page report went on to say that the heart of the park was underneath the bridge, and there would be no impact on traffic or residents. This report estimated costs to demolish the bridge at less than $500,000, but there was a caveat. The city needed to get permission from the state to remove it. That would be a stumbling block for years to come. In addition, while some residents were starting to call for change, the city council was not talking about tearing down the bridge, even as more than $1 million in private and public funds were put into park restoration. Actually, the idea of saving a "perfectly good bridge" led to some wild ideas, including blowing up the falls to let them flow away from the bridge or creating an observation deck, White said.

Meanwhile, the West End was starting to see signs of positive life. The West End Market was completely renovated from a mostly abandoned warehouse at the corner of Main and Augusta into a four-story space with restaurants, offices and shops. It gave the area an anchor to at least effect change in the West End. The attitude wouldn't change until White got into office and began lobbying for removal. Interestingly, economic development would not be the only catalyst. White found an ally in the arts community in Virginia Uldrick, who years before had spearheaded the creation of the Fine Arts Center in Greenville. This program was a way for Greenville's most artistic high school students to further expand their abilities. Students

in dance, music, creative writing and the visual arts would spend half the day at their normal school and the next part of the day at the Fine Arts Center, a retrofitted former school in the Parker area of Greenville. However, by the late 1970s, Uldrick was thinking bigger and conceived the idea of the Governor's School for the Arts and Humanities.

In 1980, South Carolina's governor, Richard W. Riley, a Greenville native, issued an executive order establishing the South Carolina Governor's School for the Arts and Humanities. It was held each summer as an intensive, state-funded arts enrichment program on the campus of Furman University. Uldrick acted as longtime director of the Furman-based summer program. She lobbied for the formation of a high school where a nine-month residential program could be held, along with additional summer programs and teacher institutes. In the late 1980s, the state legislature agreed to direct $14 million toward the building of the school if additional funds were raised from private donors. Minor Shaw, who served on the committee for Greenville, said that even though Greenville has housed the program for years, the money was available to any community in the state to pursue. Various locations were looked at over time, including near the Furman University campus, she said. Another spot was the then-abandoned Poinsett Hotel. Shaw said the idea was to renovate a few floors of the Poinsett and share space in several other nearby buildings to create an urban campus within walking distance of the Peace Center. However, both sites were considered not strong enough. The steering group could not find anything it liked until it had a meeting at the Wyche law firm on the banks of the Reedy downtown.

"We were in the law firm because we had no other place to hold meetings. After one of the meetings, Mr. Wyche called me over to a window he had in the reception area. He said, 'Do you know the land across the river? What do you think about that as the location?' I said, 'My dear, it is perfect,'" Uldrick recalled.

The land was perfect because of its history and location. It had been the Furman men's campus. It was part of Greenville's past. Uldrick also liked that the campus could be carved into the hill so that it flowed into the park, as well as surrounding businesses. In 1999, with the campus only partially completed, the school opened for its first academic year. The impact went well beyond recognition of the arts, said Bob Hughes, a Greenville developer who sat on the committee. "That is what made the West End happen because suddenly you had three hundred people down there, and their parents came on the weekends," he said. "It created a new life." Shaw

echoed those statements, calling the creation of the Governor's School one of the most overlooked parts of the downtown revitalization.

White started to use the new arts school as a platform to talk about tearing down the bridge. In an October 1997 *Greenville News* article about the school, White said, "The timing is right to think bigger about this area. I think for those of us in the city, this means to really take another look at issues like the Camperdown Bridge, as well as this park itself. We've only just begun to tap the potential." While the construction of the Governor's School was a reason to talk about tearing down the bridge, White's push came from several different directions. He had believed since his days on city council that the bridge needed to come down but was now able to start getting support on the vision as mayor. He recalls a short news piece on WYFF from that time where a reporter asked flummoxed people walking Main Street where the waterfalls were. Few could tell the reporter. White notes:

> *I was always drawn to the falls because of the history of the place. When I became mayor, it was the first place I would take visitors from out of town. You had to drive down to the river by a back alley and then go under the concrete bridge. I was impressed by their reaction, which was always strong. They would say, "Why in the world is this bridge here?" That confirmed for me that we had something special, though it was hidden away.*

The 1997 LDR report said removing the bridge was no longer relevant, but privately LDR chief Bert Winterbottom told the mayor that the bridge was stifling the river. The falls should be the major attraction the LDR report called for. Unlike a hotel or a ballpark or an aquarium, the waterfalls were permanent. They would never go away. In addition, White was beginning to hear different perspective from people that said the bridge needed to be removed and the view of the falls restored. That ranged from a college buddy to whom White showed the falls shortly after taking office who turned to him and said, "I don't care what else you do as mayor, you need to take down that bridge," to then governor David Beasley jumping along the boulders atop the falls and yelling that he couldn't believe he had never seen its grandeur. The Beasley tour was key because it related back to state control of the bridge. While Beasley was there to look at the site for the Governor's School, seeing the falls laid some groundwork down, and the governor publicly questioned why such a landmark was hidden when other cities were spending millions for such natural attractions. And finally, a city police captain named Dave Henderson took White on a tour one day. White recalled:

Mayor Knox White walks through what would become Falls Park with then governor David Beasley, whose support would help clear the way for Camperdown Bridge to be demolished. *Courtesy of the City of Greenville.*

Beasley was reportedly so taken away by the sight of the waterfalls that he climbed out onto the rocks. Here, though, he is more content to review plans with White and Pedrick Lowrey. *Courtesy of the City of Greenville.*

He took me under the bridge one day because he wanted to show me how some people actually hid under the bridge and burrowed into the hill. He has chased many a suspect only to have them disappear around the falls. His point was that the park area would never be safe or comfortable for visitors until the bridge was gone. On an entirely different note, my then nine-year-old son absolutely enjoyed climbing the rocks and around the falls and fishing below it. I used to watch him and think, if he finds this area so amazing, wouldn't other kids and families be here if that was bridge was gone?

While courting Beasley was one thing, it took a little bit of luck to actually get control of the bridge. White, Harriett Wyche and Pedrick Lowrey were actually trying to figure out a way to convince the state transportation department to give the bridge to the city. They had a meeting in Columbia arranged to make their case. It didn't make sense to ask the state for a bridge just to demolish it. The luck would come when White learned that Elizabeth Mabry, the head of the state Transportation Department, was very active in a Columbia-area garden club similar to the Carolina Foothills Garden Club. White told Wyche, who quickly realized she knew exactly who Mabry was. Wyche called Mabry to come to Greenville instead for lunch at the Governor's School with them and Uldrick so she could see the park area and how the bridge dwarfed everything around it. The plan worked; Mabry agreed to begin looking at giving the bridge to the city. "As soon as she saw it, she became out biggest ally," White said. In a letter mailed to city hall on December 30, 1997, Mabry informed White that the state had only secured easements for the bridge and that if the county planning department decided the bridge was not needed, then the state would abandon the bridge to the city. It was a major win for those in favor of tearing down the bridge, but it was far from the only thing that needed to be accomplished. White needed to get the public to back removing the bridge, and he also needed the city to actually get control of the bridge. The next three years would be about those twin goals.

With that in mind, White began to think of a way to begin generating support:

The turning point for me was when I met with Harriett Wyche, Pedrick Lowrey and the other officers of the Carolina Foothills Garden Club on a Sunday afternoon along the banks of the river. I pledged then and there

that I would make removing the bridge a priority as mayor. From then on, they were great allies in a renewed effort to reclaim the falls after forty years of being hidden. A few months later, the idea was proposed in a speech to the downtown Rotary Club of Greenville. Arlene Marcley, who was a big history buff, prepared the postcards. The history aspect was an intriguing part to me. Reclaiming the falls was the biggest and most dramatic historic preservation project in city history. It was where the city was founded, and here it was hidden underneath the bridge for forty years. We rolled out and tried to emphasize this with the Rotary Club—that it used to be the centerpiece of Greenville. It used to be where everyone went. Arlene [White's assistant] dug up some great history clips and journals and old diaries with references to the falls. There were essays from before 1920, and almost everything was about the wonder of the falls. There was a small piece in there from the 1880s of picking up someone at the train station and going to the falls. It was clearly a source of pride in the community. The response from the Rotary Club members was muted but not negative. As I would learn later, most people in Greenville had just not see the waterfall so the issue was tough to discuss.

People not knowing about the falls became a constant story as White tried to rally Greenville around the idea of tearing down the bridge. At one point, White courted help from Verne Smith, a very powerful state senator from Greer, to help sway the highway commission to give the city the bridge. He took Smith to the Governor's School to look at the park while eating. A lifelong resident of Greenville County, Smith said he would definitely help because of his deference for the falls. About a week later, White got a call from a friend who reported he had seen Smith at the falls that Sunday. The person asked Smith what he was doing in downtown Greenville, and Smith sheepishly answered that he came to see the falls because, until the meeting at the Governor's School, he had never even seen them. But it was still another strong step in taking down the bridge. The 1998 Sasaki Plan calling for the bridge to be removed was another bonus. Next came a postcard sent to key area leaders showing the falls during the early 1900s with a group of women sitting on the rocks on one side. On the card's flip side, it showed modern women standing amongst the beams of the bridge with the words, "What's wrong with this picture" along the side. There were other efforts, including a "Free the Falls" campaign that started in early 2001. The Greenville CVB did a series of renderings to show what downtown could look like in the

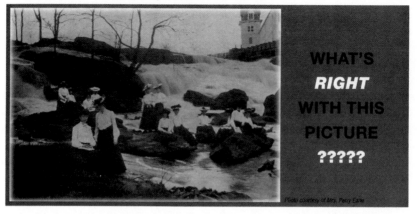

Sketching Class Historic Reedy River Falls circa 1905

WHAT'S
RIGHT
WITH THIS
PICTURE
?????

Photo courtesy of Mrs. Perry Earle

"Going to the Falls was about the only recreation that people had after they had seen the train come in from Columbia and sat on a tombstone in the cemetery."
Charles A. David, *Greenville of Old*

This postcard became a rallying point for the bridge demolition efforts in the 1990s. *Courtesy of the City of Greenville.*

future. One featured a series of gardens around the falls—a falls sans the Camperdown Bridge.

Meanwhile, a 1998 traffic study showed that removing the bridge would not have a negative impact on downtown traffic. That gave the city the power to go to the state to ask for ownership of the bridge with the sole intent of tearing it down. In March 2000, city council passed a resolution to accept the bridge into its road system. The message was clear that the bridge's days were numbered, and the bridge became City of Greenville property in October of that year.

Everyone had an opinion on what should be done. In a January 2001 story in the *Greenville News*, the venerable Max Heller—the man credited with jumpstarting downtown revitalization in the 1980s—expressed concerns, saying people might be embarrassed when they saw how low the water was at the falls. White, though, said Heller called him almost immediately to say his words had been taken out of context, and he supported the bridge coming down. One major concern was the cost. Many people said the millions that would be spent on tearing down a bridge would be better spent fixing roads. Traffic was a constant gripe. Others worried that tearing down the bridge would ruin the West End's opportunities for development. Proponents, though, fought back, saying the bridge was an eyesore; it was hiding nature; it was not

helping the gorgeous park below. Some even tried to compromise—close the bridge for two months and see what happens was one suggestion. Letters to the editor venting both sides of the issue came out every few weeks. White's office was inundated with letters. Printed. Typed. Handwritten. In bold. In all-capital letters. Sometimes they referenced other projects downtown. Sometimes they just talked about the bridge. Pro-and-con pieces.

It was during this time that White began to realize tearing down the bridge and restoring history were only part of the equation. He needed another story to tell. It had to be a story of what would come next. The Carolina Foothills Garden Club had written him asking for the city to rethink the park and expand it. It recommended a Washington, D.C.–based architect named Andrea Mains to come up with a vision for what could happen to the park once the bridge was removed. White, in turn, told the club that its vision was exactly what the city needed. Mains was hired, and local landscape engineering firm Arbor, led by Tom Keith, was brought in to help with the concepts such as building a pedestrian bridge over the falls.

White did not give up, and slowly Greenville began to listen and understand what was coming. Helping that discussion was a postcard that

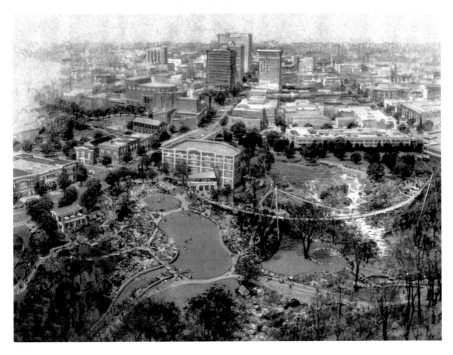

The postcard view shows the proposed depiction of Falls Park after its revitalization. *Courtesy of the City of Greenville.*

showed the "wow" factor of what the new park could look like. The idea of the postcard started when then city parks director Paul Ellis sent White a postcard showing Vancouver's Queen Elizabeth Park. He wrote on the back, "This is what we want Reedy Rivers Falls Park to look like next year." The city printed up thousands of postcards showing Mains's ideas, and they spread through the community. White recalls:

> Selling the idea of removing the bridge was a tough one: "Let's spend $13 million to create a park around a waterfalls you've never see. Trust us." Apparently, many people didn't, judging by the stream of angry letters to the editor in the newspaper and even petitions in opposition. The Carolina Foothills Garden Club and our parks director, Paul Ellis, had a great idea. Why not publish the rendering of the park and spread it around. So, for the first time, people could see the park in all of its splendor and with a pedestrian bridge! I noticed that the rendering helped change the dialogue away from whether we should remove a bridge and more toward the desirability of a beautiful new park.

In February 2001, the first public debate was set to discuss the future of the bridge, which saw six thousand vehicles a day pass—down four thousand from a decade before. It was a tough meeting with a lot of negative input, but in the end it did not deter White, who pushed forward with plans for a new, better park without a driving bridge. In February 2002, city council, with new members Chandra Dillard and Michelle Shain, made its move. In a packed tenth-floor council chamber, where more than fifty people spoke and dozens waited in the hallways, council members voted seven to zero to demolish the bridge by 2003 and create a twenty-five-acre park, despite concerns over traffic. "I was the last guy to be opposed to it," said Bob Hughes, the developer who would eventually help lead the RiverPlace development adjacent to the park. "I felt it was a traffic issue. I still do, but the park is amazing."

Two weeks after that vote, council gave conceptual approval to transform the area around the Reedy River Falls into Falls Park for $13 million. That approval included $2 million toward a "futuristically inspired pedestrian bridge" designed by a man named Miguel Rosales. The bridge would complement the surrounding scenery. The Guatemalan-born, MIT-educated architect was best known for his work on the iconic Boston bridge that was part of the Big Dig project. White remembered going to visit Rosales in Boston during the process, and the architect almost had a rock star–like

bearing amongst the citizenry. People would come up to him at dinner and ask questions about the Big Dig. They would yell his name when he walked into a bar. Rosales brought a lot of ideas such as night illumination to the bridge. It would glow at night. White admits it was a gamble that kept him up at night. If this pedestrian bridge failed in any way, he jokes, the entire council would have had to leave town:

> *The architects felt strongly that the two sides of the park absolutely must be connected and that people needed a way to more easily see and access the falls. At the same time, we didn't want to take down one bridge only to have a new bridge obscure the view of the falls. Enter Miguel with the perfect answer. He always wanted to do a pedestrian bridge. There was not one in the United States. Nothing iconic. So that is what attracted him. He told the park planning committee that his bridge design would complement the falls, not detract from them. He showed us a design with the now-famous bowed curve away from the falls. I remember sitting in the meeting thinking, "He's nailed it." He verbalized what we had been thinking. Miguel is very proud of his bridge, as he should be.*

The Liberty Bridge, as it would come to be known, features twin towers on one side with razor-thin cables completing its single suspension. It is

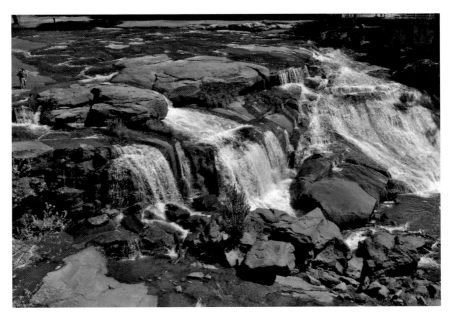

Unlike most downtown projects, the falls are a lasting feature of Greenville. *Courtesy of John Boyanoski archives.*

actually a ninety-degree span over the river, but the gentle curve of the design makes it look like a slight bend. Rosales said he wanted the bridge to look like it was floating above the landscape and make it a most distinct and visible landmark.

With a concept in place, it was time to get down to work. The project would be done in four distinct phases: demolish the bridge, install the infrastructure and footpaths, create the landscaping and, finally, build Rosales's vision.

The last day of the old bridge's reign was August 5, 2002, when a silver Toyota drove over it before nine interlocking plastic dividers were put on each side of the bridge, along with purple and gold "Waterfall Rescue Zone" signs—a tongue-in-cheek nod to what was happening. The city even posted direction signs to help people who still predicted traffic gridlock downtown. On the day of the closing, White and city manager Randy Oliver went up with binoculars to the tenth floor of city hall to watch for traffic disruption. "There wasn't the first sign of a traffic backup. There was nothing," White said. Demolition started almost immediately after the closing, when crews using diamond-tipped concrete saws began dismantling the bridge section by section, piece by piece. Work would last almost eighty days as almost six million pounds of concrete and steel from the old bridge were sliced away, ripped up and sent to a landfill. The idea was to protect the falls at all times, even as forty-four-foot-high bridge supports were moved. The entire park was cordoned off from pedestrians except for the crews working on the pedestrian bridge and the city employees planting the new gardens. White recalls:

> *The park was constructed behind a fence for more than a year. Nearly every day, Tom Keith was on the site. He practically lived in the park, making probably hundreds of big and small changes to the plan. He showed me all of his special sitting areas and the intricate pathway system designed to make being in the park such a pleasure. One day, he asked me to climb over a newly constructed wall near Main Street to view the site and said to me, "I'm so close to this project that I can lose perspective, so I have to ask you, is it as good as I think it is?" I said, "Tom, it is even better than you think." We always laughed about the conversation years later whenever we saw the crowds enjoying the park.*

While many people avoided the park during the construction, the people who had been proponents saw the potential. Businessman Jay Spivey said

he used to take his Sunday morning newspaper and a cup of coffee to go and look at the empty park. His main thought was that soon it would be filled with people. The local media ran numerous stories counting down the days until the park reopened. Updates on construction came every few days. Stories of the history of the area filled downtown.

As the big day approached and Greenville held its breath, White got to immediately get down to the pedestrian bridge:

> *The bridge engineering team was from Stuttgart, Germany, and was an all-female team. They were consummate professionals and all business. So I was surprised one day to get a call from the lead engineer encouraging me to come to the site to see the last suspension cable applied to the bridge. She said, "You need to be here. When we attach the last cable, the bridge will either work or end up in Spartanburg."*

The new bridge opened to the public in September 2004, almost two years after the city began the demolition of the old one. About three

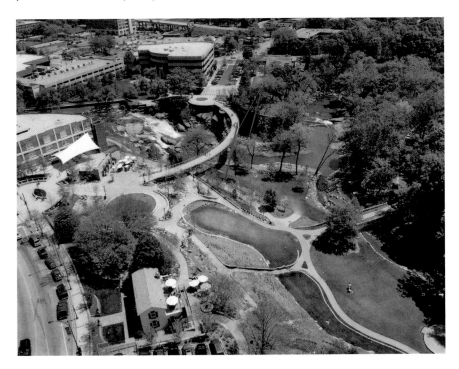

A shot of Falls Park just before it reopened to the public. *Courtesy of the City of Greenville.*

Mayor Knox White and Miguel Rosales stand on the finished Liberty Bridge. *Courtesy of the City of Greenville.*

hundred people packed into a plaza on the Main Street side of the bridge to hear White, Rosales, Mains, Keith and more talk about the process of reclaiming the falls. The crowd cheered when city council members cut the floral-decorated ribbon. White remembers:

> *Opening day was something to see. Throngs of people came down to walk across the bridge. It was an interesting phenomenon. The waterfall that once was the postcard of Greenville and was the centerpiece of downtown that had been hidden away for forty years—it was back. To have so many people walk across that bridge to really experience the waterfall for the first time…You could see it on their faces. It was a mixture of surprise and pride. Another thing that stood out to me was we worked hard to make the park handicap accessible. Many people in wheelchairs came and still do. The falls are now accessible to everyone.*

The impact of the Falls Park revitalization cannot be overstated because it changed the city's destiny. The falls were a maligned part of downtown,

and now they are the symbol. Figuratively and literally, the meandering of the falls is part of the city logo. The bridge has become one of the most photographed, if not *the* most photographed, image in the city. It is used day and night by pedestrians—some strolling and some running. It brings the park together. The park itself has helped transform Greenville, from Shakespeare plays in the summer to outdoor movies in the fall to weddings in the spring to road races in the winter. Heavy rainstorms bring the ubiquitous person in the kayak risking life and limb by going over the falls. A warm day brings revelers. It's not just the falls, either. The Liberty Bridge has won numerous awards, including the Arthur G. Hayden Medal for outstanding achievement in bridge engineering, while the park has been honored with the Urban Beautification Award from the American Horticultural Society and the Virginia Hand Callaway Award from the Southeastern Horticultural Society and was a finalist for the Urban Land Institute Urban Open Space Award. White says:

> *From the first day it was announced, Falls Park was intended to be the centerpiece of downtown. It took a good downtown and made it a great downtown that people from all over the country come to see. But in many ways, it is still the story of Greenville reclaiming what it always had. Vardry McBee loved the falls. It was always the pride of the city, until pollution and a bridge hit it away for forty years. We owe Harriett Wyche and the Carolina Foothills Garden Club all the thanks for seeing the potential when no one else did. But their vision could not be realized unless the bridge was removed. We had to move beyond talking and do it. Now, we have an attraction that is uniquely and authentically our own. That is the real power. All of these groups come to Greenville now from all over the country. That didn't happen until Falls Park. It was a game changer.*

However, the impact was more than just visual and cultural. It was economic. Within a few years, the new downtown baseball stadium was constructed, and RiverPlace, a $65 million mixed-used development along the river, was announced. While the main part of RiverPlace had been on the city's calendar of dreams for more than twenty years, it wasn't announced as officially being ready for work until early December 2004. White notes:

> *RiverPlace was Tommy Wyche's long held vision for the river. He considered many proposals over the years and wisely waited until the right moment.*

The removal of the bridge and the creation of Falls Park gave the green light for sure. He then chose the right team of developers to own the site. Only Bob and Phil Hughes could have pulled it off. It was just too complicated for anyone else. The city was an eager partner in the process. Our role, however, was more than building a parking garage. It was making sure the river itself was fully accessible to the public now and for future generations. That was controversial and many people misunderstood what were we doing and why. As one council member, Chandra Dillard, said whether RiverPlace ever happened or not, we had to open the river to the public.

The project was rolled out (and continues to roll out) in a series of phases that have included high-end condos, restaurants, a hotel (Hampton Inn), offices, boutiques and low-cost artist spaces fronting the Reedy. It may be

Renderings for RiverPlace with a water feature that was almost impossible to describe to the media. *Courtesy of the City of Greenville.*

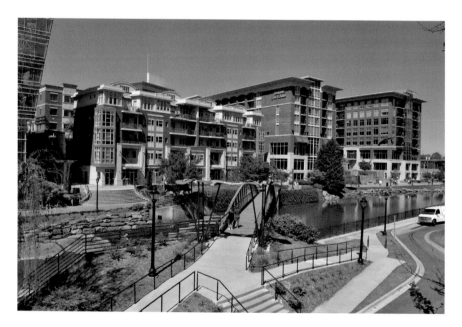

RiverPlace helped bring people to the river in the 2000s. *Courtesy of John Boyanoski archives.*

best known for a series of man-made waterfalls and fountains cascading through the middle of the complex. One of the more interesting stores is Michelin on Main, the only retail Michelin souvenir shop in the United States and one of two in the world. The other store is in Paris, France.

The park also brought numerous pieces of redevelopment to the West End as many buildings that once had plywood covering the windows were turned into cafés, restaurants, art galleries and small stores. The park sparked interest in the river as well. Runners and cyclists lobbied hard for an old rail line along the river to be converted into a trail that is now known as the Swamp Rabbit, which runs from Lake Conestee to Travelers Rest. Downtown Greenville happens to be a major hub on the trail. In addition, projects such as the $63 million Joan and Ray Kroc Center opened in the West End, in part because of the development of the falls.

According to White:

> *The lesson from Falls Park was be bold. Take decisive actions. It is curious to me that tearing something down brought something back. The next mission is to keep going up the river. The most distinctive part of our city is the river and the falls.*

Of Mice and Main

At its heart, Greenville is an art community, which is somewhat odd yet fascinating considering its history as the industrial epicenter of South Carolina. Art and culture were for towns and cities on the coast or a place like Columbia, which had a large university and minds looking for more than business. Even in the Upstate, it would appear that Greenville historically was behind the times. Nearby smaller communities, such as Newberry and Abbeville, have beautiful historic opera houses on their town squares. Yet looks can be deceiving; Greenville's love and appreciation of the arts runs deep. Greenville's art community reflects its people. It is understated and personable, with a slight European flavor accentuating its southerness, and all done on a human scale.

"Here we are a city of sixty thousand people in the northwest corner of South Carolina," said Alan Ethridge, executive director of the Metropolitan Arts Council. "But think about the amenities we have."

Ethridge says arts are part of the community as much as the Reedy River is its birthplace. He traces them back to the formation of the Greenville Little Theatre more than seventy years ago and the creation of Heritage Green—a library, art museum and theater initially—in the 1950s and 1960s as a place for people to enjoy culture in one convenient tree-covered area. "Let's think how far the arts community has come in this time period. Look at what the arts have done in several aspects. Urban revitalization first and foremost," Ethridge said.

Urban revitalization is a key part of what has happened downtown, White said. The Peace Center is a large and shining example of how the

investment in arts has changed Main Street, but arts play a larger role than that. Public art has been a major part of the Main Street revitalization. That runs the gamut from year-round white lights in the Main Street canopy of trees to abstract pieces near the falls to a series of historic bells at RiverPlace to the numerous statues downtown. It is the statues that were part of the city's effort to capture a key, but hard to define, part of the LDR plan: giving downtown an identity. That personality is the statues, which highlight Greenville's history as well as put that history at eye level, where people can enjoy it. White said the LDR plan called for Greenville to have more of a personality, but it also calls for a historic feel. White saw public statues honoring Greenville's past as the natural extension of this mandate.

The question became where to start and who to start with when it came to these statues. Like many things in Greenville, the answer is Joel Poinsett. In life, Poinsett was a scholar and leader. De Tocqueville spoke highly of him in his writings—sharing stories from chance encounters on lonesome roadways all the way to the White House when Poinsett introduced him to President Jackson. In modern Greenville, though, Poinsett (or to be precise, his statue) started the public art explosion along Main Street and is the reason all the statues have a certain feel. But that is jumping ahead a little. First, one needs to understand what public art in Greenville looked like before the early 2000s, when Poinsett found his home on Main Street.

There wasn't much—very little, to be more exact. Like most southern cities, Greenville had its share of Civil War statues erected in stone in honor of the Lost Cause. They were part of a trend nationwide that considered public art to be honoring heroes of the past and essentially were permanent parts of the urban landscape. The Greenville monuments and statues eventually, though, moved from directly on Main Street to the edge of Springfield Cemetery, just outside the Central Business District. Eagle-eyed viewers with a knowledge of southern history will notice that the general standing twenty feet high on a stone column is facing west. Statues of southern soldiers are supposed to face south.

The 1970s saw some early stabs at public art—modernistic, abstract pieces found homes in front of city hall and what is now Court Square. The reviled City Hall Plaza has some small pieces as well, including some terra cotta remnants of the old city hall built into a back wall. Unlike the Civil War monuments, these pieces of public art were banished to storage rooms and other parts of Greenville, including Stone Avenue and Roper Mountain.

But aside from that, public art was not something readily done and held on to in Greenville. Not until 1997, when the LDR report surfaced again. One

of Bert Winterbottom's keen observations was the distinct lack of public art. In an effort to make the downtown have a more cultural feel and show its character, art was needed, the report stressed. The city started slowly with some small projects led by then director of parks and grounds Paul Ellis. He came up with the idea of putting bells in the trees at the intersection of Main Street and McBee Avenue. On windy days, the ringing of bells is a small reminder of that first installment of art. In 2000, a senior at Christ Church Episcopal School named Jim Ryan came to White with an idea that led to one of Greenville's quirkier pieces of art: the famed "Mice on Main." They are nine tiny bronze rodents hidden in the nooks and crannies of Main Street. Clues to finding the mice can be found in most downtown stores, and it is common to see groups of people clutching papers full of hints as they crane their necks looking for the mice, which now have names that all begin with the letter M. White said it was his assistant, Arlene Marcley, who set up the meeting with the hint that the student was bringing something the mayor would like. The teen explained his idea and told about how close it was to reality. He just needed a little bit more money and a blessing from the city. White agreed to the idea, and noted, "You never know where the next good idea will come from." In an example of life imitating art imitating more art, the idea of the mice came from the classic children's book *Goodnight, Moon*. *The Mice on Main* later would become a book featuring a whimsical version of Ryan's story.

While the bells were going up in the trees and a series of quotes and quips were being encased in brick in front of the new Poinsett Plaza on Main Street, the first real breakthrough in public art was being done as part of a sketch for the under-renovation Poinsett Hotel. The architects showed a fountain in the courtyard of the hotel front, a statue of a person, a horse and then another fountain. White asked what the statue was for and the architect said it should be of someone historic. The mayor's poker face must have betrayed the fact that Greenville hadn't done any historic figures recently and the architect asked in a thick accent, doesn't Greenville have history? White recalls:

> *The LDR report specifically recommended public art that tells the story of Greenville's history. Then came the design for Court Street by the same architectural design team that was working on the Poinsett Hotel. The lead designer, who was French, wanted us to consider bringing back Court Square and including a statue. This would involve tearing up this entire section of Main Street and creating a brick plaza around*

the hotel. It was a novel and bold idea and it fit exactly with the earlier LDR recommendations.

Did Greenville have history? For a city that had spent the better part of two decades tearing down old buildings, keeping its head under water when it came to the Reedy River Falls and constantly looking for an attraction, the question stung deeply.

If there was to be a statue, White, with the assistance of Arlene Marcley, focused in on one person: Poinsett. It made perfect sense. The hotel that was being renovated was named after him. There are records of a "save the Union" speech written by Poinsett being read in Court Square during the 1850s. While the statue made sense from a civic standpoint, it didn't from a financial one. The city didn't have the funds or the political capital to be spending several thousand dollars for a statue in 2001. White began calling people he thought might be willing to donate funds to the project. He was asking for small donations, thinking that would be best. He soon got a call back from Dan Bruce, a local business leader. White recalled that Bruce's tone made it sound like he was not going to donate, but he was quickly surprised when Bruce said he wanted to fund the entire project in order to honor his parents. Once Poinsett's statue was announced, White got a challenge from one of the historical societies. Why Poinsett and not Vardry McBee, the person who laid out the plans for downtown almost two hundred years ago? The group met with White on the tenth floor of city hall to express its concerns. White said it was a great idea, but the society would have to raise the money for it. The group thought the city had paid for the statue. Once they realized it would be donations that built a statue on Main Street, they began fundraising for McBee. It was a challenge that was soon given to other groups coming to the city looking to honor someone, somewhere, in bronze.

Meanwhile, work started on the Poinsett statue. Local artist Zan Wells was commissioned to create the statue. Wells, whose other works included a child reading at the Greenville County Library, the downtown mice and a large suitcase detailed with clothes, camera, binoculars and shoes, called *Annika's Rush*, outside city hall, ran into one major issue when re-creating Poinsett. No two renditions of him looked the same. She studied oil paintings, a bust and a vivid, written physical description to get a feel for what he might have looked like in real life. Those features included hooded eyes, a dimple and a sharp nose. She depicted Poinsett in period costume, with his overcoat draped over the bench and his hat and gloves resting next to him, after consulting

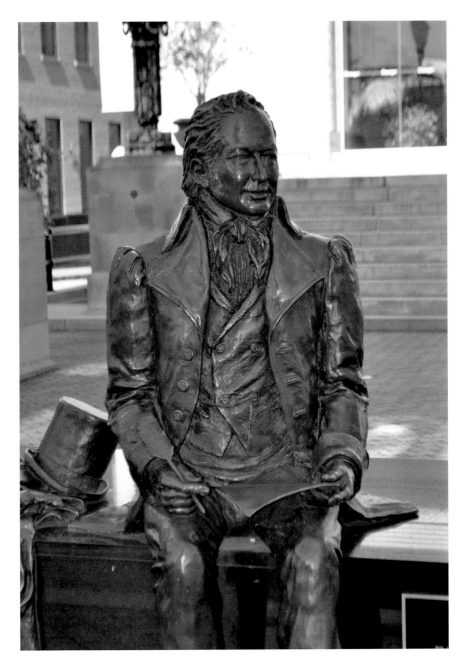

The bronzing of Greenville started fittingly with Joel Poinsett, one of Greenville's most famed residents of the 1800s. *Courtesy of the City of Greenville.*

with Furman University. He is writing a speech with a quill pen. Poinsett was sitting, something very rare but deliberately done by Wells. She wanted the sculpture to be part of the city streetscape and something people could enjoy. The statue was unveiled officially in the summer of 2001. During the unveiling, White said Poinsett was a man of many talents—statesman, naturalist, scientist and diplomat—and he had an affinity for Greenville. It made sense to honor him. Authentic, definitely, and a lot had to do with him sitting down. White notes:

> *The original design for Court Square was a traditional standing figure. Zan Wells suggested a sitting figure so that people could interact with it. It was a remarkable idea. From the first day Mr. Poinsett was unveiled, people of all ages have sat with him and really spent time reading about him. That statue is a great history lesson about his life and early Greenville. It is also one of the most photographed sites in downtown and unleashed a whole series of "pedestrian-friendly" public art on Main Street.*

McBee's statue soon followed in early 2002, and in a unique location as well. It is almost exactly across Main Street from Poinsett in another corner of Court Square. Considered the father of Greenville, McBee constructed more than one hundred buildings in Greenville County and built a textile mill along the Reedy River. He gave land to five downtown churches, all of which gave $5,000 toward the $35,000 cost of the statue. It was created by sculptor T.J. Dixon of San Diego. McBee and Poinsett were friends in real life, and the saying around Greenville is that, based on the proximity of their statues, they are keeping their old discussion alive.

Greenville's next statue would have been considered majorly controversial if it were anywhere but Greenville. The city honed in on a statue for baseball legend "Shoeless" Joe Jackson in the West End. It was a bold move on many levels, none of which had to do with the fact that Jackson was banned permanently from professional baseball for his alleged involvement in the 1919 World Series fix. No, the boldness came from the fact that, instead of at the heart of the renovated Main Street, the Jackson statue was going up in the middle of the West End, which at the time was a few years away from being a major part of downtown. The second was that, unlike McBee and Poinsett, Jackson was not an educated statesman or political giant. He was a ballplayer from a mill village whose lack of literacy likely cursed his baseball career. White said the idea for Jackson started because so many people called his office looking for information on Jackson, including directions to his

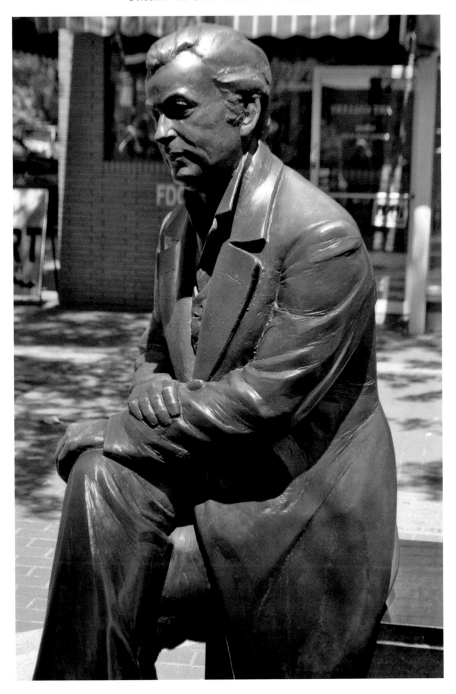

Vardry McBee, the father of modern Greenville, has a statue across the street from Poinsett. Both men are sitting and looking at each other as if in conversation. A conversation interrupted by traffic, but a conversation just the same. *Courtesy of the City of Greenville.*

grave. Baseball fans apparently believed Jackson was the only thing anyone in Greenville could care about. But with that brought interest from an interesting group of characters to help make the statue a reality. No offense to Poinsett and McBee, but they have never had hit Hollywood movies made about their lives à la Jackson with *Eight Men Out* and *Field of Dreams*. Jackson is an icon of American mythology. The idea of honoring Jackson started with an exhibit in the city hall main lobby but grew when Dr. Bob Jones III, then president of the Greenville university that bears his name, came to see White. Jones brought along sculptor Doug Young. Together, they unveiled a model of a potential statue for Jackson. White remembers calling for Marcley to get in there quickly because she had become an ardent Jackson fan. She nearly fainted, White said. As it turns out, Jones was a big baseball fan and said he would help lead the fundraising efforts for the statue. The story of his statue brought national headlines to Greenville, as former Los Angeles Dodgers manager and Baseball Hall of Famer Tommy Lasorda spoke at the July 2002 dedication ceremony, along with then U.S. representative (and later influential U.S. senator) Jim DeMint of Greenville, who was leading a campaign to get Jackson reinstated to professional baseball in order for him to become eligible for the Hall of Fame.

The almost eight-foot-high statue shows Jackson finishing a powerful swing with his "Black Betsy" bat, his eyes lifted upward gazing over the West End skyline. A glove is tucked in his back pocket, and yes, he is wearing shoes. Soon, more statue ideas popped up, and it started to become an issue of where to put them all. Not every street corner needed a statue, but it was believed that more art was needed. The city council created an Arts in Public Places Commission to help guide future art installations. Part of the reason was to keep Greenville's artistic growth going forward, White said. One of the key things the city has learned is that any and all art has to be real and part of the community. That is where the idea of historic street statues finds life. White says:

> One of the biggest traps that cities fall into is this sort of Disneyfication of their downtowns. Their version of what an ideal Main Street should look like. People can sort of sense when it is not real. You can't do the latest gimmick. It can't feel like it was all done at once.

It would be a few years before the next statue came to be. This one was of Dr. Charles Townes, a Greenville native, Furman graduate and best known as the father of the laser, for which he won the Nobel Prize in 1964. This

The statue of "Shoeless" Joe Jackson helped spark the West End's rally. Yes, he is wearing shoes here. *Courtesy of the City of Greenville.*

statue was to be located at the corner of Main Street and Camperdown Way, just across the street from the entrance to Falls Park. The interesting thing was that this statue actually had little city involvement, unlike the past three statues. It was led by the Townes family in Greenville, as well as developer Phil Hughes, who tells an interesting story of the history of the statue. A Greenville native, Townes remembered a story his father used to tell of one of his Furman classmates who came up with the idea for a laser while sitting on a park bench and won the Nobel Prize for it. The story stuck in his head for years. Hughes said he "never got art" growing up but gained an appreciation after living in Italy for a few years in the 2000s. He saw the statues and the history and began to think of ways to make his hometown have the same feel. He remembered his father's story and did some research on Townes. He talked to White, who agreed that Townes was a good choice. So, Hughes called Townes, who was living in California, and asked what he would think of a statue. Hughes recalled that Townes was very flattered and suggested that maybe a laser could come down and "bop him on the head." The statue idea would not get that grand, but it did give Hughes the idea of bouncing lasers from several buildings in downtown, which can now be seen in the West End.

Like Poinsett, Zan Wells designed the Townes statue. With a living person, she was able to re-create specifically what Townes would have looked like the day he came up with his "aha moment," all the way down to the stripes of his argyle socks, which can be seen on the statue. More than two hundred friends, relatives and colleagues came from all over the country, gathering under a canopy on the windy corner of Camperdown Way and Main Street for the opening ceremony in April 2006. Gray clouds hung over the city, but the rain held off as the crowd spilled onto the sidewalk. The statue shows Townes at the moment of his creation of the formula for what he called a MASER. The "M" stood for microwave energy, and it would later become an "L" for light energy. Townes's statue shows him sitting on a bench with an envelope in his left hand and a pen about to touch it in his right. The formula is written on the envelope. The actual bench that the statue sits on comes from Franklin Park in Washington, D.C., which is the same park where Townes came up with the formula in 1951. That came about when Hughes called the National Park Service on a whim to see about the benches. Maybe Wells could re-create the exact look of that? As it turns out, the benches were about to be removed, and the person on the phone said Hughes could have one if he wanted. So he sent an employee up in a pickup truck to bring a bench for Townes to sit on in Greenville.

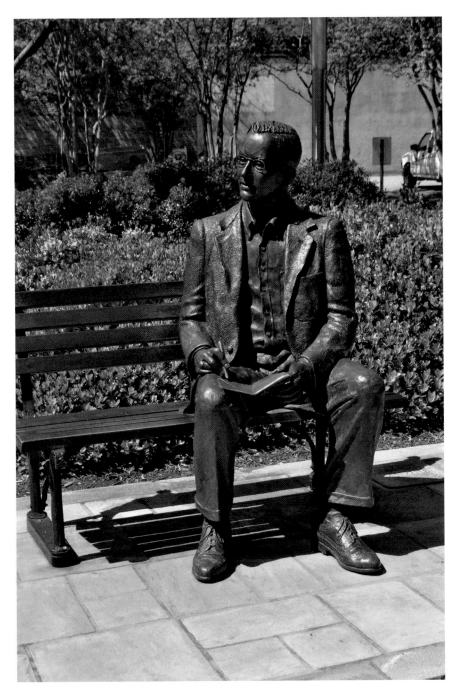

The statue of Dr. Charles Townes helped spark interest in Greenville's connection to the laser. *Courtesy of John Boyanoski archives.*

White notes:

I asked Dr. Townes if he could be depicted standing up since we already had so many sitting figures. He was adamant that he must be sitting because he was sitting on the park bench when the formula came to him. He got his wish. Phil Hughes managed to acquire actual park benches from the National Park Service for the site. A few years later, we received an astounding demand from the Park Service explaining that the benches were not actually authorized to be moved to Greenville asking for us to return them. With the help of our congressman, we refused. The benches are still here.

Townes was followed by a statue erected at the corner of Main and Broad Streets of Revolutionary War hero Nathanael Greene in August 2006. Again this was a private campaign led by local businessman Ken Scarlett. Greene gained famed for saving the South during the war, eventually leading to American independence. The interesting thing about the Greene statue is that it was erected with the no-questions-asked stance that Greenville was named after the general. The "green" in Greenville had been debated for decades, but the statue puts the question to rest. The statue is located next to the Greenville News Building, and the square surrounding the statue has markers for several other Revolutionary War heroes. In addition, a tri-corner-hat-wearing, drum-holding mouse is planted at Greene's feet.

One of the unique things about each of the statues was that questions were always asked about where to locate them. Poinsett was kind of obvious, but the rest caused some concerns. The next statue quickly had a location—the corner of Main and Washington Streets—but also a debate over what the statue should look like. It started when the mayor realized all of the statues were white men and some diversity was needed. He put together a committee of African American leaders in the community to come up with a fitting statue. Several ideas were discussed, but none gained traction until Thurman Norris proposed a statue honoring Sterling High, which had been Greenville's African American high school before integration. But even that drew a debate. Some wanted to show a drum major, which for decades had been the most coveted position in the school. The school band was a reason the panel quickly selected the corner of Main and Washington. During the annual Christmas parade, that was the corner where the Sterling band would put on the bulk of its performance—to "show out," as the phrase went. Greenville's African American community would set up at the

corner to see the show. It was a point of pride. However, a monument honoring all Sterling students was chosen instead.

The statue was dedicated in November 2006 (almost forty years after fire gutted the school) in front of hundreds on a Sunday morning. Captured in bronze are two students walking down a set of steps, looking hopefully toward the future. Just before a blue sheet was pulled off the statue, graduates stood and sang the alma mater, wrapping it up with "Sterling High School—bless her name." And the grads, many of whom went on to become community leaders, shrieked like teenagers at a pep rally. It was the "show out" corner once again.

In May 2009, the last (at least to date) bronze statue was erected on Main Street honoring former mayor Heller. The bronze, larger-than-life casting depicts a middle aged Heller, his feet appearing to stride forward and his right arm extended, wearing his signature doubled-breasted suit, his finger pointing across Main Street directly at the Hyatt. The monument was funded by Friends of Max on Main, comprising about 140 private and corporate donors, and was unveiled on his ninetieth birthday. The statue is surrounded by a series of columns affixed with bronze plaques depicting highlights of his life and career.

White admits that public art does face some big decisions and problems that the city needs to tackle. The biggest is how many statues can one downtown manage? A person can trace the history of Greenville from Greene to McBee to Poinsett to Jackson to Sterling to Townes to Heller over a three-quarter-mile stretch of Main Street. Seven statues is a lot of bronze, and that doesn't account for all of the mice, *Il Porcellino* (a replica of the famed boar found in Florence, Italy) in front of Poinsett Plaza, the Pete Hollis statue a few blocks away from downtown and the numerous other pieces of public art up and down the street. Other projects and proposals are sure to come, including one that White wants: a statue honoring the Cherokee tribe that called Greenville home long before Richard Pearis set up his gristmill. White said Pearis should be honored as well at some point. There have been talks of statues for Greenville natives turned wildly popular late twentieth-century governors Richard Riley and Carroll Campbell. Who knows who else will get the funding to be immortalized at some point in the future?

Greenville's immersion in the arts goes beyond statues and has become a major part of Greenville's day-to-day fabric of culture. One interesting aspect is Art Crossing, a series of small art studios built facing the Reedy River on the bottom level of the massive RiverPlace development. To help

make space available for painters, photographers and sculptors, the actual units are no bigger than parking spaces and rented out for a similar monthly rate. The first phase opened in 2006 with a second wave in 2008.

Art is a catalyst for tourism as well, said Chris Stone, president of the Greenville Convention and Visitors' Bureau (CVB). Sitting in his office on the second floor of the Innovate Building in the West End, he grabbed a book containing artist renderings created in the late 1990s during one of the LDR reports. This book has followed Stone through three downtown CVB offices for a reason. The book was his idea after being tasked by LDR's Bert Winterbottom to come up with a way to give downtown a personality, create an attraction along the river and look at convention space downtown. The book is the culmination of those assignments, on which Stone worked with Lynn Craig, a Clemson professor. Stone told Craig his ideas, and the professor sketched them into stylized renderings of what Greenville's downtown could become. It runs the gamut from envisioning the waterfalls without the Camperdown Bridge to open spaces filled with public art.

"To me, that was the start of seeing street art," Stone said.

Public art is a major part of the visual attraction of downtown Greenville. *Courtesy of John Boyanoski archives.*

Alan Ethridge, executive director of the Metropolitan Arts Council, said Greenville residents' philanthropic nature has been a key to the growth of the arts just as much as leadership's allowing the arts to prosper.

"The city council and city leaders have been phenomenal. They get it. They get the fact that it is important for the Peace Center to have an expansion. That it is important to fund the Metropolitan Arts Council in terms of its marketing and advocacy efforts. It's important that the Metropolitan Arts Council continues to thrive as a granting agency for the arts. The other great thing about the people in this city is they are always open to new ideas, such as art in public places. They don't lose sight of that. Just because it isn't new doesn't mean that it is not worthwhile."

Diversity of the arts is a major component as well, Ethridge said. The Peace Center brings in Broadway shows, while the Greenville Little Theatre re-creates the classics using local talent. The Warehouse Theatre and Center Stage offer contemporary, professional shows. The Upstate Shakespeare Festival brings the Bard to life each summer in Falls Park. Café and Then Some is a local troupe that has been zinging and roasting Greenville life for more than thirty years. "Regardless of what your taste in theater is, there is something to whet your appetite there," Ethridge said. The Artisphere Festival is a major international art show every spring that, in less than a decade, has been one of the ten best shows in the country, while the annual Open Studios program allows local artists the ability to show their skills to the community. Artisphere came about due to the vision of business leader Henry Horowitz, who pitched the idea of an arts festival modeled after one in Oklahoma City.

Then there are the various pieces of art downtown that are not bronze but are permanent:

The sculpture *Rising Star*, donated by Llyn Strong of Llyn Strong fine jewelry, was designed by internationally renowned artist Bob Doster. At the time of the commission, the slogan for the city was "A Rising Star Is Greenville." The corten steel piece is located on the corner of Main Street and College Street.

Untitled 2002–2003, also known as the dancing or running sculpture, or "Gumby" because it looks like a red version of the children's toy, this painted steel sculpture, designed by Joel Shapiro, is an imaginative piece located at Wyche Overlook near the Liberty Bridge.

Tucked in the corner of Poinsett Plaza, visitors will find two towering metallic spires. Philip Whitley sculpted the art piece *Mountain Fall* to portray the mountains, with the curvilinear space between them representing the water.

This art at NOMA Square is part of the growing trend of public art downtown. *Courtesy of John Boyanoski archives.*

Orbital Trio, a modern piece of art located at NOMA Square outside the Hyatt, was created by Clemson's John Acorn. Erected in 2013, it has become one of Greenville's newest signature pieces.

"If you look at how our population has evolved over the last thirty years, the arts have to evolve with that. The arts have to serve people," Ethridge said.

But the underlying message of public art for downtown is that it helped people make a connection. The average person will keep walking as long as they see something visual. Before public art became a dominant part of the scene, walking more than a few blocks along Main Street was an unknown proposition. There may be a restaurant down the street worth eating at, but why walk past old buildings with no sense of place? White says:

> *Public art has been a connector for downtown Greenville in so many ways. That is a key that a lot of cities don't get. They don't see the importance of those pieces that help someone walk from the next block to the one after that. It's a visual show that makes people stop and look and think. Art should speak for a community and reflect a community. There is no better venue for it than Main Street.*

Chapter 9
Safe at Home

It was April Fools Day, but no one was smiling, let alone laughing. City council members had called a press conference on the ninth floor of city hall to announce a result of its years-long negotiations with the Greenville Braves to come up with a solution for a minor-league baseball stadium. It didn't take much to realize that the answer to the future of the Braves in Greenville was a resounding no. There would be no new downtown stadium. There would be no renovations to the Mauldin Road field. There would be no more Braves after twenty-one years of the AA Atlanta affiliate filling summer nights with the sounds of wood bats on baseballs. The news was beyond depressing. The G-Braves were a Greenville icon to many people, even if attendance numbers hadn't shown it the last few seasons. This was the team that brought Chipper Jones, Tom Glavine, Javy Lopez and scores of other big-league stars through the Upstate. It was the place where Dale Murphy came for an exhibition game. It was where John Smoltz came on rehab assignments, bringing thousands of autograph-seeking fans in tow. The Atlanta Braves were a southern team—the only major-league team between Houston and the Atlantic Ocean—and Greenville was a southern town. It was a good match.

But more importantly, the Braves were proof that Greenville could do great things when its leaders put their minds to it. Professional baseball had been played for almost seventy years in Greenville before the Texas Rangers' affiliate hightailed it out of town in 1972 and its field, Meadowbrook Park, burned down. Greenville was a baseball ghost town until business leaders

Opening night (not day) for the Greenville Drive in 2006 drew a packed house. *Courtesy of the City of Greenville.*

put together a plan to lure the Braves' AA affiliate here in 1984. It was a match made in heaven for more than twenty years, but now it was ending on April 1, 2004. The city could not close the deal—and would not, either, based on the demands of the Braves. But two things happened that day. Mayor pro tem Lillian Brock Flemming got up in front of the media and proclaimed loudly that baseball in Greenville was not through by a long shot. Greenville would get a new team. The other big thing was that Knox White got a phone call from Columbia. Not from a political leader from the state capitol but from the general manager of the Capital City Bombers. The message was simple: don't make any decisions because we want to come to Greenville.

Greenville quickly realized that professional baseball teams—actually, their moneymen—saw the city as a place they wanted to go. In a short time, dozens of different franchises were actively courting Greenville and the rest of the region. And that led to another round of political intrigue and battles before a downtown site was chosen and a Class-A Red Sox affiliate called the Drive (even that was a battle) plopped down and called Greenville home. White notes:

The saga of the baseball stadium was the longest and most controversial project the city has undertaken. There were enormous financial hurdles, lawsuits and little public support for the longest time for a baseball stadium downtown. But there was one constant—city council members shared a conviction that downtown is where it belonged, and that made all the difference.

Greenville's first professional team was known as the Mountaineers and came to be in 1907 in the Class-D South Carolina League. It was the lowest rung on the baseball ladder. The Mountaineers lasted one season and were replaced by the Spinners in the Carolina Association in 1908. That league consisted of neighboring county rivals Anderson and Spartanburg, as well as North Carolina teams in Greensboro and Winston-Salem. The Spinners' name recognized Greenville's textile boom. While the Carolina Association folded in a few years, the Spinners' name stayed on as some version of a Greenville nine played in several leagues, but mostly in the South Atlantic, until the early 1960s. Affiliation with professional teams changed every few years, and the Greenville squad produced its fair share of legends, including Wilcy Moore, who spent 1926 with the Spinners and then somehow found himself the staff ace of the 1927 New York Yankees—a team often called the greatest of all time—twelve months later. Hall of Fame manager Tommy Lasorda toiled here in the 1950s while a Dodgers' farmhand and, more importantly for him, met his future wife. In 1963, the Spinners' name was dropped in favor of the Braves, which took over the team's affiliation. Then it was the Mets and a visit from Nolan Ryan, who showed the first inkling of becoming baseball's strikeout king in the summer of 1966. He won seventeen games, lost only two and struck out 272 batters. The big highlight was striking out 19 in one game before he moved on to bigger and better things. Two years later, it was the Red Sox, followed five years later by the Rangers for one last season in the sun.

Then, it was nothing for more than a decade until a business leader named Sam Phillips found out that the Braves AA team in Savannah was looking to move. He organized a campaign to get the team to relocate that included more than fifty thousand postcards handed out by bankers, Little Leaguers, business owners and mothers that stated, "I'm making my pitch for baseball." It worked, and the city committed to building a new park on Mauldin Road for the 1984 season, five miles away from downtown and really surrounded by nothing at all. It was a bowl-style field with seating for six thousand and parking for just about as many. A jumbotron hung

in centerfield (apparently at the request of Murphy), and the back wall consisted of plywood colored with the hues and logos of advertisers. It was an OK stadium—nothing to get nostalgic about but somewhere a family could head on a Sunday afternoon and enjoy a game.

There were some great highlights as the AA Braves became the proving ground for scores of future Atlanta Braves just as the team became a 1990s dynasty. The 1992 Braves are hailed as one of the top one hundred teams in minor-league baseball history and the first to win one hundred games in the Southern League. They simply dominated, winning both halves of the season by more than ten games. They posted a .669 winning percentage that year and were led by future Braves superstars Chipper Jones and Javy Lopez. Two years later, though, the crowds got huge. NBA legend Michael Jordan came to Greenville as a member of the Birmingham Bulls in the spring of 1994 during his two-year retirement from basketball. Needless to say, his first game in Greenville broke attendance records at Municipal Stadium.

People liked the Mauldin Road stadium. At least, that was the feeling until the late 1990s. The G-Braves' general manager, Steve DeSalvo, enquired with the city whether upgrades could be made to the field in 1998. Better drainage. Improved lockers. And maybe, just maybe, some enclosed seating to help generate more revenue. The city looked, and, well, things got a little crazy rather quickly. The G-Braves ran as their own baseball team on the operations, but they were owned by the Atlanta Braves, which meant, eventually, Time Warner. That meant a lot of headaches down the road.

The first inkling that something was changing came in March 2000 in a *Greenville News* story penned by longtime sportswriter Ed McGranahan. Reggie Williams, a Seneca native and the quiet force behind construction of the Bi-Lo Center, said she had approached the Braves about building an 8,500-seat downtown stadium similar to Turner Field in Atlanta. The discussions had actually started two years before, she said, and were based on the fact that the stadium had lost the ACC Baseball Tournament in the mid-1990s due to a lack of luxury suites. She also said she would be willing to lead a renovation of the existing field. Bob Wolfe, the Braves' senior vice-president, said the club's future was not contingent on a new field, and the organization wanted to stay for "many, many years." He started a healthy dialogue. Mayor White was quoted as saying there was an appeal to having a stadium as part of the city skyline but stressed that no taxpayer money would be involved. That stadium idea got lost in the shuffle, though, when another group proposed a stadium in the West End off Academy Street. It was slated to be the jewel of an entertainment district that would open

up West Greenville to redevelopment. After several months of excitement, including hints that an AAA team could come, the project fell by the wayside due to legal complications. The Mauldin Road stadium continued to age, and the Braves were going from subtle requests for improvements to hitting the proverbial panic button over and over again.

In July 2001, the Braves' general manager, Steve DeSalvo, sent a letter to then city manager Randy Oliver outlining the numerous improvements needed for the Mauldin Road stadium, including a new playing field, a warning track, better lighting, new outfield fencing, a new scoreboard, a picnic area with berm seating, a new brick veneer for the stadium to give it a retro look, suites, a gift shop, a restaurant and tunnels to clubhouses. DeSalvo put the cost at about $18.3 million, but that would be cheaper than trying to build a new facility. While the Braves did not mention anything about moving the team and simply wanted renovation, other signs showed warnings, including the abrupt departure of the Braves' Class-A team from Macon to nearby Rome. The Braves said an aging stadium in Macon and little support from local officials were the reason. The feeling was that Greenville could be following the same path, which didn't lead to home plate.

Behind the scenes, though, White was working for more public money. In February 2001, he and DeSalvo were part of a contingent that drove to Columbia to talk to state legislators. He sent a letter to county council chairman Dozier Brooks asking for assistance in October 2001. His message was that if the county was looking at addressing its parks and recreation needs, it should consider a new professional baseball stadium. That letter later became the basis of a *Greenville Journal* story in November 2001 in which several council members thrashed the idea of the county government putting money toward a city project. White later sent a letter to county councilman Scott Case, who, as vice-chairman of the council, was one of the most powerful people in Greenville at the time. White said it was his understanding that several county council members had been talking with the Braves about renovating the stadium. The letter, dated March 26, 2002, said there was support for between $5 and $10 million in state money from a bond bill, and White asked for further assistance from the county. Case, though, would routinely thwart city efforts toward baseball in the following years.

In the meantime, many national scholars began to question the idea of baseball stadiums being actual economic development tools. An April 2002 article in *American City and County* cited numerous reports of how public funding of sports stadiums was not a good investment. The fact was that the

amount of public subsidies negated any real growth that came from spurring new development.

In the spring of 2002, the city sent out a request for proposals to give the stadium/baseball new life. ScheerGame, DLR Group and Heery International responded, and their work was sent to a citizens' task force dubbed the Blue Ribbon Committee.

The Blue Ribbon Committee, chaired by the esteemed George Fletcher, began meeting that summer. Few people could bring Fletcher's business ability and love of baseball to the table. As head of Fletcher Group, he led a successful environmental engineering company headquartered in downtown. He had served as the chairman of the Greenville Chamber of Commerce board of trustees. And he was a baseball nut; his office walls were lined with mementos of his lifelong love of the game. He coached Little League baseball for ten years and had been a season ticket holder for the G-Braves since he moved to Greenville in the 1980s. Other committee members included Stephen Jones, future president of Bob Jones University; local attorney Tom Traxler; publishing magnate Bern Mebane; and Deb Osborne, longtime athletic director at J.L. Mann High School.

The group had an RFP that gave a lot of stipulations, including no use of property taxes; a firm could offer a new stadium site as long as it was in the city; and no deal could include legislative action. Part of the reason for the stringent funding is because the city had recently forked over $7 million in bonds to save the region's largest convention space, the Palmetto Expo Center, from closing down. The city was strapped to spend money on a potential baseball revival as well.

While three groups submitted, there actually were five proposals. ScheerGame was led by Carl Scheer and Williams, who had combined to build the Bi-Lo Center a few years before when everyone believed a "coliseum" could not be built in Greenville. Scheer is one of those names in sports that resound more with insiders than general fans. A native of the cradle of basketball, Springfield, Massachusetts, Scheer started his career as an assistant to NBA commissioner William Kennedy. He jumped to the ABA in the early 1970s, winning executive of the year three straight years. He started the slam-dunk contest in an effort to promote his biggest star, David Thompson, and then helped negotiate the NBA-ABA merger in 1976. He spent the next fifteen years in a variety of roles: general manager of the Denver Rockets and, later, the Los Angeles Clippers; commissioner of the CBA; and then original general manager/president of the NBA Charlotte Hornets, where he met Williams. However, he realized that owning a team

meant more than being the business figurehead, so he moved into minor-league hockey.

ScheerGame offered two plans: $56.4 million for a new stadium, sports center and a nature park with the help of the Conestee Foundation at the existing site. The stadium alone would cost $36.3 million, the proposal said, with both private funding and a projected county hospitality tax.

The second plan called for a $27 million stadium to be the lead piece in a development called The Point at the intersection of I-85 and Woodruff Road, which was when Woodruff was traffic laden in Greenville and not yet traffic gridlock. Both sites would feature 7,372 seats, 300 club seats and 31 luxury boxes, as well as picnic and play areas. An additional 1,360 seats could be added on surrounding lawns and terraces. Also, the entrance plaza would include a 750-square-foot "Hall of Fame," with exhibits extending around the stadium.

Heery also had a pedigree to be reckoned with, as this Atlanta-based firm had been the designer of Turner Field, as well as the Georgia Dome. It offered a $12 million renovation that would include the demolition of all facilities behind the stadium seating. New suites and club seating would create a VIP area that would double as a covering for stadium seats. A new entry plaza with a "museum kiosk" and retail store, second-floor Class-A office space, new team clubhouses and a picnic area on the first base line would be included. Heery also offered a second plan at $18 million that called for a complete restoration. Expanded suites and club seating would double as a covering for stadium seats, and a "party deck," new lighting and scoreboards would be included.

DLR Group was a local group led by Bob Farris, one of the proponents behind the Southern Connector. Its plan called for a $16.8 million complete retrofitting of the Mauldin Road site—basically, all that would be saved would be the bowl portion of the current field. The new stadium would include sixteen skyboxes, a "Greenville Baseball history area," seven thousand seats and the possibility of adding three thousand more.

Each proposal relied on $3 million from the city and an expected $8 to $9 million from stadium revenues for a stadium that Braves officials said would have to cost at least $18 million in order to meet AA standards. The plans all had pros and cons, and at one point Fletcher told the *Greenville Journal* that the committee wished it could take parts of each plan and put them together for a baseball stadium masterpiece. DLR would later publically note that the ScheerGame proposal was using property taxes and was proposing a site outside city limits, which were foul balls according to the original proposal sent from the city.

In August, the group recommended The Point. The G-Braves' management agreed. However, the committee said ScheerGame needed more time (ninety days) to develop finance plans. That turned into a problem as city council balked at the idea because the plan called for creating a special tax district that would add $17.4 million to the public debt. Instead, city council decided to give all the groups more time to respond, and an October 7 deadline was set. Debate, as expected, was heavy as people railed against the city, traffic and the Braves in short order.

The committee again failed to act in an October 14 meeting. The next day's *Greenville News* stated a decision would likely be made in two weeks, but it could be early 2003 before a recommendation was made. The idea was that maybe new county council members would be more apt and willing to lend their support. In addition, it was felt that a consensus wasn't there because each group had financial issues. Instead, two weeks brought a decision as city council voted to start seeking new partners for a Greenville baseball stadium to keep the Braves—rejecting the three bidders (per the advice of the baseball committee) and prompting a letter from DeSalvo saying he wanted to see the stadium process completed before further discussing the team's future. Essentially, all five plans were tagged out as they rounded second.

After a closed-door session in January 2003, councilwoman Michelle Shain recommended that the city hire a negotiator to help lead the charge. She said it would help raise funds, as well as serve as an olive branch to county council. A few weeks later, the *News*'s sports columnist Bart Wright scathingly wrote that with baseball season slated to start in less than a week, the cry of "play ball" would be a "death rattle" in Greenville, where no politicians would shed tears.

But at the end of March, the city hired ScheerGame to act as negotiator, and the firm was given 120 days to shore up the financing and construction plans. However, this was not a green light to build at The Point, even though Scheer expressed an interest in the site. The only bargaining chip he had was the $3 million from the city. Again, no property taxes were to be used, and the county was adamant it was not going to help.

Everything would change, though, later that month, and it had nothing to do with the city's plans. The school board decided to buy an old, abandoned lumberyard site in the West End for $1.9 million, despite city government protests. The so-called Wickes site had been targeted for redevelopment for years, but no plans had been able to come to fruition. The school district saw the site as the natural extension of Greenville High School, whose students and parents had been promised new athletic fields for years, to no avail. They

correctly pointed out that they had the worst facilities of any county high school because they were so landlocked in the urban core. School district officials said it would be about two years before the site could be cleared and a high school baseball stadium could go in its place. The purchase was authorized on April 22. The reality was a high school field was never going to be a good fit for the West End at that location. The city and many West End merchant were against the idea because they believe site needed something larger there that could anchor redevelopment. White recalls:

> We wanted a downtown stadium, but where? The river corridor was the first choice. When that became unachievable, we started the search all over again. We considered the old Memorial Auditorium site and a site near the Greenville News Building. We looked at any place we thought was big enough for a ball field. Then George Fletcher suggested that we look at the old lumberyard in the West End. It was an open yard filled with debris and blighted structures next to the railroad tracks. It seemed too small to meet professional baseball standards, so we called the minor-league commissioner's office for advice. One cold and blustery winter morning, a team of surveyors from the minor-league office measured the site while a few of us on city council huddled together and watched. They walked over to us. We were standing about where the pitcher's mound is now. One of them said, "Well, it fits, but just barely. You don't have a foot more. My partner and I have been talking, and we think this might be the finest spot for a baseball stadium we've ever seen."

The story made it to the media in early June. Fletcher predicted the West End stadium could bring 250,000 people a year to the West End. The school district property would be purchased, along with some additional sites to put together 7.2 acres. Fletcher said there were challenges but no deal breakers. Fletcher credited the Greenville High parents with the vision that a baseball field could go on the site and that Red Raider teams could share the field. GHS parents were cautious, saying they only wanted equality with the rest of Greenville County Schools. The underlying premise was that they didn't want a minor-league field to share. It should be noted that GHS and Sterling, the pre-integration black high school in Greenville, actually played games at Meadowbrook when it was a minor-league field in years past. DeSalvo was not optimistic, either. The Braves didn't want downtown but at least would be willing to listen. The city, though, was adamant that Woodruff Road was off the table. The next two months brought more negotiations, and by August,

city council came out strongly in favor of the West End site. On August 12, the school board approved a letter of intent to cooperate with developers for a "joint-use" stadium. Scheer and Williams would lead the deal.

However, no sooner was the plan brought up than the board of trustees voted five to five for it, meaning it was a foul ball again. Still, there was hope, as the school board did give the green light to a plan that would essentially swap the Wickes site for a site closer to the high school, close Vardry Street and force the district to pursue land elsewhere—namely Dunbar Street. Later that month, the Braves and the city began talking about extending the lease on the current stadium—something that hadn't been done in five years. DeSalvo optimistically said he hoped it wouldn't be a long process. A deal was reached in early September: one year at Mauldin Road with options for the 2005 and 2006 seasons. There was a glimmer of hope that if a stadium deal was worked out, it might take time to build. However, DeSalvo later added that the team would listen to offers from other cities.

Meanwhile, a consortium of leaders from the surrounding neighborhoods around the proposed site called for the school board to sell the lumberyard (or at least swap it out) so that a professional stadium could be built. Their reasoning was economic: a high school field would do nothing for the revitalization of the area. Whispers of possible deals floated through the autumn breeze. School board chair Tommie Reece compared the wheelings and dealings and machinations to the classic baseball bit "Who's on First?" in a guest letter to the *Greenville News* in October. A series of community meetings in October brought mixed reactions from residents. African-American leaders said the stadium would leave the historic Allen Temple AME a boarded-up church next door and drive people from the community. In early December, Jane Sosebee, then chairwoman of the Upstate SC Alliance board of directors and regional director for BellSouth, touted the benefits of keeping the Braves in a *Greenville News* editorial. She called the organization one of the Upstate's shining stars and mentioned the team's work with various nonprofit groups, including the Boy Scouts. One attorney in town even wrote a letter to White, Reece, Scheer, Williams and others suggesting mediation, something normally reserved for a lawsuit.

It all came to a head in a packed school board meeting a week before Christmas. More than 150 people attended, including White, four other city council members, city staff, West End merchants, church leaders, parents and players decked out in Red Raider letterman jackets. The meeting actually started on a Tuesday night and went into Wednesday when midnight struck. That meant a new day had started, which prompted Councilwoman Diane

Smock to remark to the other members there that it was now her actual birthday. About twenty-five people survived the six-hour wait to hear the school board agree, seven to five, to a land swap as opposed to a purchase plan. The city would get the West End property in exchange for purchasing properties and moving homes. It was 3.6 acres for 5.0, but it meant minor-league baseball was alive.

"That was one of the longest meetings ever. But it gave us a chance for downtown baseball," White said.

In the middle of all of this, council hired a new city manager. Jim Bourey was a government veteran with stops in nine cities in nine states during his career. While there were numerous projects going on that needed attention, baseball was considered the most critical. "I would definitely say that was one of the first things discussed," Bourey said.

Negotiations continued in early January, away from the public spotlight. The Braves at one point tried to get all the area's key movers and shakers into one room to make a pitch for public support. Meanwhile, Plant met with Braves officials off and on. However, Scheer and Williams left the project in February 2004, and in early March, it came to light that a suburb of Jackson, Mississippi, called Pearl was making a play for the AA Braves. It was promising that the baseball stadium would be part of a major entertainment area that would include a Bass Pro Shops just off the Interstate. Mississippi governor Haley Barbour was personally involved in the negotiations. That region had lost its AA team in downtown Jackson in 1999 and called it a tragedy. It was soon learned that Cherokee, Georgia, also was making overtures to the Braves. Barbour's involvement highlighted what had been a major hindrance for baseball in Greenville: the city had been tackling the issue on its own for too long. White even faxed a seven-page letter to Bob Faith, chairman of the state Coordinating Council, asking for funding help, citing the money Mississippi was giving the Braves. No reply was given.

A mid-month poll on GreenvilleOnline led to an interesting push for civic pride. DeSalvo e-mailed about fifty of Greenville's heaviest political and business hitters asking them to vote in the poll, which asked if the city should fight to keep the Braves. He didn't ask people to vote yes, just according to their consciences. The e-mail quickly was forwarded and forwarded again. Restaurateur Carl Sobocinski was one of the people who forwarded it. While he didn't remember doing so a decade later, he did recall his feelings about the stadium deal. He felt it was best suited for somewhere off Interstate 85 and that keeping the Braves—a team so associated with Greenville, the Carolinas and the South—was a necessity. Some took it as a sign that the

Braves genuinely wanted to stay, but DeSalvo would not comment on that part publicly. A few days later, *News* columnist Jeanne Brooks wrote about how a looming April deadline for a decision from the Braves had baseball fans on the edge of their seats.

Council had a last-minute, almost three-hour-long meeting on March 30 to make a final pitch to the Braves. It called for the city to build an $18 million stadium using funding from the sale of the old stadium, naming rights, special tax district financing and a split of revenues. It failed, as the Braves' Mike Plant rejected the offer at five o'clock in the morning. Bourey had recommended during the meeting that the council not take a counter offer from the Braves because the financing was too much of a liability for the city.

Reaction in Greenville was despondent. The next day's *Greenville News* told the story of Charlotte W. Bailey, a G-Braves cashier whose home was a practical museum of the team's history. A picture on the front page just below the fold showed White, Flemming and Coulter with grim looks on their faces during an impromptu press conference on the ninth floor of city hall. "That picture tells the whole story," White said. The city declined to talk about how the financing went wrong, but White would later say that every time city officials upped their offer, the Braves' management in Atlanta would take less from the table. Interestingly enough, a secondary story in the *News* that day prophesized that getting an AA team back was going to be difficult. The story, by longtime baseball writer Willie T. Smith, further added that Greenville was likely to become a Class-A team in the South Atlantic League, sometimes called the Sally League. A *Baseball America* writer quoted in the story said, "Greenville is not going to go one day without baseball." John H. Moss, the league's president, said he remembered when Greenville was a Sally League member but stopped short of commenting on the possibilities.

But one person was commenting on the Sally League's changes—not publically but in a phone call to the mayor's office. White recalls:

> *We tried to put on a good face when the Braves made it official that they were leaving. We were pushed to the limit in terms of financial commitment, and there were no eager partners—state or county—coming forward to help. It was a long day, a very long day. Walked back to my office dejected. Ed Jenson of WORD radio, a great baseball reporter and announcer, offered me some surprising encouragement. "There will be a lot of teams that will want to come to Greenville. You just wait." Within thirty minutes of the*

announcement getting out, I had a phone call from the general manager of the Capital City Bombers. I was feeling as low as can be, and the first thing he said was, "Mister Mayor, don't make any commitments on a new team today. We want a chance to make a proposal." Just minutes after losing the Braves, we had a first expression of interest. Over the next few months, informal proposals came in from all over the country from teams wanting to relocate to Greenville.

But on April Fool's Day, reaction from the community was at times withering, including one sarcastic letter to the editor "thanking" the city for shafting baseball fans in favor of West End revitalization. Others, though, said that true baseball fans would flock to a downtown stadium because it was a location everyone knew.

The city kept its talks with prospective groups quiet for a few months. At least fifteen groups contacted the city, including an AAA team. One group was a Dodgers' affiliate that included Lasorda as part of its ownership team, and the Hall of Fame manager said he would even consider coaching for the first two years, White said. However, while a lot of this was happening behind the scenes, the community was engaged. A round of editorials and letters to the editors criticized county council for not chipping in. County councilman Cort Flint, whose district covered much of downtown Greenville, chimed in that the county needed to pitch in more on local projects but added that his column in the *Greenville News* was about more than just the pros and cons of the Greenville Braves. Also keeping the story in the spotlight was the fact that the Braves were about to start their final season in Greenville. Numerous stories painted a melancholy picture of the Mauldin Road stadium. A piece by George Fletcher, who had led the 2002 committee, called for people to embrace one last season. Sadly, his was not going to be a glorious send off to a beloved team but a prolonged, poorly attended death march into oblivion.

While the city interviewed prospective teams behind the scenes, the Braves closed out their final season with a 63-76 record. As was customary for years, Little League players stood with the Braves players for the national anthem, and in the end the fans rushed the field to congratulate and commiserate. There were fewer than 2,000 people at the last game on Labor Day weekend 2004. It capped the poorest-attended season in Braves history: 142,433. Still, the team went out in style with a 3–0 win over the West End Diamond Jaxx.

And then things got really crazy in the late fall of 2004. Essentially, there were three proposals buzzing around Greenville.

The AA West Tennessee Diamond Jaxx, a Chicago Cubs affiliate and, yes, the team the Braves beat in their final game, was working with the City of Mauldin on a $20 million stadium off Interstate 385 and Butler Road. Team owners were putting in $3 million, and the City of Mauldin would bond out $11 million.

Mandalay Entertainment was shopping a $26 to $28 million stadium in a similar fashion to the late 1970s Clint Eastwood, finger-flipping monkey vehicle *Every Which Way You Can* as Greer, Powdersville and Spartanburg County were all being courted. Mandalay had approached the city as well but did not like the West End site. It was later revealed that Mandalay was representing the New York Mets.

Then there were the Capital City Bombers and a proposal with the City of Greenville to build on the Wickes property. That plan called for a six-thousand-seat stadium sandwiched by private development. The stadium was to be built by team ownership and be a Boston Red Sox affiliate.

The story of how the Bombers found Greenville stemmed from a similar deal its management team was working on in Columbia. Sitting in his Fluor Field office that features a signed jersey of Jim Rice and a picture of Knox White from opening day, the team's president, Craig Brown, explained that his baseball business partners knew about Greenville, but he had no real inkling of the city. However, they learned about baseball stadium projects while spending several years trying to build a new stadium to be shared with the city of Columbia and the University of South Carolina. Negotiations got so far as a memorandum of understanding that even included who would open the stadium for batting practice if USC coach Ray Tanner felt it was needed at 5:00 a.m., but they died on the vine when the City of Columbia couldn't make its financial plans work in September 2004. "Just when that was falling through, we heard about Greenville. Of course, that led to what became considered the 'wild, wild west' in minor-league baseball circles," Brown said. White said he and council listened to a lot of proposals, but the Bombers gave the offer they couldn't refuse or quite believe:

The new city manager, Jim Bourey, conducted an orderly review of all of the teams' offers. He was confident that Greenville was a desirable place to be and that we could get a good deal. We insisted that our stadium must be mixed use so that it could operate all year with condos, restaurants and retail. After years of hearing the Braves ask and ask for more, it was a pleasant surprise to hear teams actually offer to fund parts of a stadium. But the Bombers' ownership made the best offer of all—they offered to

build a mixed-use stadium at their own expense! We were stunned. So, I called the mayor of Chattanooga, Tennessee, to ask if was true that these same owners built their new stadium at no cost to the city. He confirmed it. "We never worry at all about the baseball stadium. They do a superb job." Jim Bourey sent the word back that they were our pick. The funds we had set aside for baseball could now go into infrastructure in the West End. It was the beginning of a wonderful partnership.

Still, each proposal had pros and cons ranging from size to cost to delivery to location. Everyone in Greenville seemed to have an opinion, and many of them contradicted. One *Greenville News* editorial cartoon showed two baseball players with their tongues hanging out running straight at each other with their eyes on a ball. The message was clear. It was a powder keg waiting for a match—one lit by outgoing county councilman Dozier Brooks. After being defeated in the Republican Primary, Brooks was heading toward the end of eight years on council in November when he offered an ordinance to create a multi-county industrial park, which would help the City of Mauldin raise an additional $6 million to build its stadium. Brooks, who in 2002 tried to raise a countywide referendum saying that tax money should not be used on baseball stadiums, said he was doing so to keep AA baseball in the Upstate. Greenville city leadership countered that they would go to county council to remind all of Greenville that the downtown plan didn't cost them money. It was not lost on city officials that the county could have created a multi-county industrial park in helping to save the Palmetto Expo Center a few years before. The date of that meeting was slated for November 30.

A few days before the November 30 special meeting, the *Greenville Journal* ran an editorial that urged county council to think about the taxpayers citing that two of the three stadiums had plans that required no public dollars for stadium construction. While AA was supposed to trump all other stadium proposals in theory, the *Journal* urged council not to go that route by writing, "Why spend public funds on a ball stadium the community can get for free? The answer will tell a great deal about this council's willingness to act in the best interest of taxpayers."

Then there was the meeting. Raucous doesn't describe the scene. There were charges of secret meetings, name calling, showboating, sidebars and councilwoman Lottie Gibson breaking into song, "Can't wait till January," a reference to three council members stepping down after being voted out earlier in the month. In the end, council passed an ordinance to create a multi-county industrial park (basically, a large tax break to the tune of $6

million) to build a stadium anywhere but in the city of Greenville. Council members reasoned that they were evening the playing field between the three groups since the City of Greenville had a special-purpose tax district to aid its plan. It would take years for any other part of the county to make up the amount the city could put forth.

A scathing *Greenville News* editorial called it the "December Surprise" and blasted away with both barrels when editors wrote, "It will go down as one of the most shameless and arrogant displays of power in the council's history" and as an "unprecedented display of brazen political power coordinated by two council members who had been voted out of office." The editorial went on to essentially damn the majority of council to a life in purgatory, or at least a baseball equivalent, citing that the group avoided public debate and hatched plans in private before gleefully springing them on an unsuspecting public. While part of the venom was over use of accommodations tax, the baseball issue got full attention. "The council majority that refused to help save the Greenville Braves demonstrated a newfound love for baseball—one so great these council members are now eager to divert future tax revenue to help build baseball stadiums." The *Greenville Journal* ran a similar scathing editorial, this time calling for council to apologize. "It was a shameful, embarrassing spectacle," Susan Simmons opined.

At the same time, the three new Republican members of council, Butch Kirven, Jim Burns and Tony Trout, wrote a letter to Mike Moore, commissioner of minor-league baseball, to delay a decision on Upstate baseball. They said the new council did not support the tax incentives, and a delay would give the new council members time to repeal or substantially change them. The letter stated that setting aside money for Mauldin was a "short circuited" process, and they wanted time in January to review what happened. On December 10, the four Democrats on county council sent a letter to minor-league baseball in support of the Kirven, Trout and Burns letter to hold off ratifying a new baseball team in Greenville. At the time, it was believed New Year's Eve was the decision date to select a new team in Greenville.

That same week, Mayor White wrote personal letters to Xanthene Norris and Bob Taylor on county council. Neither was written on city letterhead, and White stressed he was writing as a friend, not as mayor. His message was simple: baseball was a profitable business that used governments to underwrite their costs. He asked that Greenville County not fall into that trap and not support the multi-county industrial park. The park would take one of the potentially most affluent areas in Greenville off the tax rolls.

Three days after that letter hit the mailbox, county council again was meeting at its University Ridge chambers on a bluff overlooking downtown and a few blocks from the proposed city site. The council officially passed the funding mechanism but was almost immediately slapped by a restraining order signed by a circuit court judge. The order was on behalf of a lawsuit by Ned Sloan, who almost twenty-five years before had helped spearhead the construction of the Hyatt. In the intervening years, he had become the state's foremost taxpayer advocate. In 2008, *South Carolina Lawyers Weekly* wrote of him, "But Sloan's impact on South Carolina jurisprudence has been neither hidden nor small. Over the past five years, no private individual has brought—and mostly won—more original jurisdiction and other declaratory-action appeals before the S.C. Supreme Court than the 79-year-old retired contractor and father of four." The *State* newspaper's Cindy Scoppe opined, "A word to the wise: if Ed Sloan sues you—or even comes after you outside of court—settle. Quickly. Don't waste the courts' time or taxpayers' dollars fighting what will, with what appears to be increasing certainty, be a losing battle."

Needless to say, a lawsuit from Sloan carries some weight. Sitting in the packed audience, Sloan watched for almost five hours as council members debated bullet proofing their measure, were told they were being sued by Sloan, went into private session, came back out, voted and then got the restraining order. Sloan's five-page suit was actually over the procedure of how things were done, not the actual funding. The case was eventually dropped when the judge who signed the restraining order lifted it, saying there would be no irreparable harm. While council members devoured themselves, Allen Temple AME's Richburg landed two guest columns in the *News* and the *Journal*, again blasting the city for not working with him and his congregation. A letter from attorney Michael F. Talley to minor-league baseball offices in Florida stated that a West End stadium, "with all of its attendant noise and parking problems and the closing of a portion of Green Avenue, would be a nuisance in our neighborhood." Talley went on to write about a state law that prohibited the sale of beer or other alcoholic beverages from being sold within three hundred feet of a church inside city limits. White recalls:

The church issue. Lillian took the brunt of this. We had numerous long meetings with the board. Hours and hours. We walked into the lion's den. They had legitimate concerns. They have a historic church, and the city wants to build a baseball stadium directly next door? In their minds, it's

going to look like Mauldin Road. It's going to be a big, hulking, ugly building right next to their beautiful church. Plus, the issues of services and the like. We saw that. Well, I go to Greensboro and see this beautiful stadium. What is directly next to the stadium? A historic Methodist church. It's just as close as AME was going to be. I couldn't believe it. I grabbed the mayor and asked what this was? He said they were really opposed to it. They sued the city. I said, "What!?" He said, oh yeah, but they love it now. They get parking revenue. So the next morning, I went right to the church, opened the door, walked down the hall and quite randomly the first person to appear was the pastor. I explained who I was and what was happening in Greenville and wanted to know what the church's relationship with the stadium was. He laughed out loud and said, "We need to talk."

The pastor explained that the lawsuit was a bad idea, and the stadium was the best thing that could have happened to the church. "I couldn't believe it. He was great," White said. Meanwhile, a letter to the editor in the *Greenville News* from attorney Matt Kappel praised the city's plan because it would regenerate the area. The other plans would be "islands" where attendance would dwindle after the newness of the stadium wore out. White's office at city hall was inundated by e-mails and letters—some offering support, some disgust and at least one suggesting that the West End site be a symphony hall.

Minor-league baseball's New Year's Eve deadline came and went, which led to a very anxious January in Greenville. The Southern League even approved the Cubs' AA affiliate's move from Tennessee to Mauldin. However, three days before Valentine's Day 2005, and sixty-one days before opening day, the city got a love letter of sorts from minor-league baseball. The Bombers were given the Greenville market.

"We were the only ones who were aggressive enough or crazy enough or probably a little of both to approach the city with the plan for us to build the stadium," Brown said.

The next morning's *Greenville News* showed a picture of a smiling trio of White, Brock-Flemming and Coulter greeting the team's then managing partner, Frank Burke, at city hall. It was a decidedly different picture from the front page from roughly a year before when the same trio had glowered for the cameras. The stadium would serve as the new perfect bookend along Main Street that started with the Hyatt, extended to the Poinsett Hotel and then to the Peace Center across the river to Falls Park. A final piece. An exclamation point. Of course, the stadium wouldn't be ready until 2006, but the team's management was optimistic. They joked at a city hall press

conference that they would use a black marker to erase part of the "C" in the team logo, making it a "G" in full acknowledgement that the Bombers, like the Mauldin Road stadium, were temporary stays. While professional baseball gave no elaboration for the choice, the city believed it was because it was a straightforward business deal. However, some suspected it was the unique design. The new field would be a replica of Boston's Fenway Stadium, complete with a mini "green monster" measuring thirty feet high, hand-done scoreboards and similar dimensions. It made sense. Greenville's was going to be a Boston Red Sox affiliate stadium to the tune of $10 to $15 million built by the team, not the city. In addition, a private development built by Centennial American Properties would include restaurants, offices and condos along the Main Street entrance. This mixed-use portion of the stadium would give the site life year-round.

Over time, the stadium would incorporate numerous bits of Upstate history from the 500,000 bricks for the façade being reused from abandoned mills to the city's original fire station being used as the ticket booth/merchandise store. In a guest column in March, White opined again that the stadium was about more than just baseball. Despite victory in the great Greenville baseball war, there were nagging complaints out there. Parking was bad. The neighborhood was worse. The stadium was going to fail. White countered that the stadium was going to be a lynchpin for not only the West End, but also the neighborhoods surrounding it: "A stadium will do for West Greenville what the Hyatt, the Peace Center and Falls Park have done for North and South Main Streets. We are united with the people of West Greenville who are embracing the future instead of fearing it." In a nutshell, White was asking people to once again trust city hall and show faith in a group that had brought back the Poinsett Hotel and redesigned Falls Park.

However, consternation was still high around Greenville. There was a feeling that the community was stepping backward by embracing a lowly single-A team as opposed to an AA team and an AA community. The feeling was territorial. Birmingham, Chattanooga, Mobile, Montgomery and Raleigh were the cities that Greenville was competing against in terms of economic development, and they were AA or higher. Greenville needed to be AA or higher.

It was an odd summer for the Bombers. On the field, they went 72-66 to get the first winning season in Greenville since 1997. They drew a little more than 115,000 people—even worse than the Braves the previous year, as people didn't quite know what to think of the a low-A team playing out near Mauldin. The scoreboard got hit by lightning late in the season, which

made the team resort to writing scores in chalk on the right field wall. At the end of the season, someone scrawled on the wall that next year would be five miles downtown with an arrow pointing toward Greenville.

That winter saw the construction of the stadium in the West End. It created an unusual sight because for the first time in generations, people were going into the West End to watch something being built. And it wasn't just Greenville folks taking notice. Governor Mark Sanford sent an e-mail via an intermediary about throwing a first pitch in a game. White answered via e-mail, "As to baseball, that first pitch is going to yours truly, so I am getting some practice pointers this week."

It soon came to light what this stadium actually meant in terms of redevelopment, and people got excited. Almost every building in the West End sported a banner of some kind with a phone number to call for lease or rent or purchase. Other businesses said they were getting calls constantly to see if they were interested in selling their locations. Everyone talked about it being an anchor that would spur growth. Every move was watched and debated—looking back on the questions is almost humorous. One story worried that the baseball stadium would be a hangout for teens because it sold beer so close to the high school, a question that Councilwoman Flemming shot down by noting that beer sales to youths had never been a problem on Mauldin Road. According to White:

> *We had seen all of these places where baseball had sparked development in downtowns. These were cities that were no bigger than Greenville. We looked at a lot of them. Dayton. Durham. Chattanooga. We saw what they did right and what they failed on. The baseball stadium was really a test for the city. We had a vision, and we knew that vision would work. So many people who said the stadium in a West End was going to be a failure. We saw it differently.*

The countdown to the opening night gripped the city like no opening night since the Peace Center fifteen years before. Four-page slicks were printed and passed out that showed numerous places where people could park vehicles and then walk to the game or, if they parked at County Square, grab a trolley bus to the game. The Bombers' name was gone and replaced by the moniker "Drive" and a stylized red G as a logo. Even that was a public relations battle. There was a time when the Drive was not particularly liked by most baseball fans in the Upstate. Hard to believe now when "going to a Drive game" is as much a part of the

Fluor Field has become one of the most celebrated baseball stadiums in America. *Courtesy of the Greenville Drive.*

Greenville vernacular as going downtown. Part of the reason was that people wanted, and almost got, the name the Joes. The whats? The Joes would pay homage to Greenville legend "Shoeless" Joe Jackson, he of the downtown statue and whose house was moved across from Fluor Field. Brown said the Joes was definitely the first choice to replace the Bombers, and they even went to MLB commissioner Bud Selig with the idea, knowing that there could be a problem since Jackson was banned from baseball for his involvement in the 1919 World Series fix. Brown recalled that Selig didn't shoot the idea down immediately. Minor-league baseball actually rejected the name first because of the connection to Jackson but allowed the team's management to request that Selig reverse the decision. Selig eventually sided with caution and prevented the name.

The Drive name was chosen because it reflected Greenville and the Upstate's automotive history, as well as the business community. However, that name was criticized because many in the community felt a "name the team" contest should have been held. Online media polls even came up with names such as the Grits, the Greensox, the Fireflies, the Fire Ants, the Copperheads and the Flying Squirrels. Brown said, though, that there was no time for a contest, and Drive was chosen internally. The reason there was no time was because there was a stadium to be built.

Brown compared the time from the June groundbreaking to the April 6 grand opening to a marathon race where adrenaline kept everyone going. There was no opportunity for a soft opening because baseball had to start on time. "We didn't have a plan B," Brown said. That meant a lot of teamwork and long hours. Bourey recalls that pretty much every utility known to man had some project in and around the stadium, and about a week before the first pitch, Bell South lines were cut by crews working on the sidewalks, curb and gutters along Main Street. "They said they could not be recovered for two weeks and the trench would need to be kept open on the side of the street. I did say that is not going to happen. We covered the trenches with metal plates and temporarily paved over the metal plates and returned later when the ditch could be filled in," Bourey said.

Opening night was April 6, 2006. Helicopters circled the field to show live shots on the evening news. "Shoeless" Joe Jackson, or an actor impersonating the West Greenville native, stepped into the left-handed batter's box after coming in from left field in a haze of smoke. He made his famous swing and then sent two baseballs over the right field fence, where fireworks erupted. The air was filled with the aroma of hot dogs and beer, as piped-in music by K.C. and the Sunshine Band clashed loudly with the New Orleans spiritual brass music of the Holy Land Sounds, who were set up near the front gate. White, who wore a Drive jersey with his name and the number 1 in red on the back, asked the crowd what they thought of the ballpark. A loud cheer came from the bleachers before White lobbed out the first pitch.

"Once people adopted the team and saw the connection, it worked," White said.

The season was a rousing success. The team drew 330,078 fans—smashing the previous Braves' record by more than 100,000. That was just the beginning. In 2007, the team drew 339,356. In 2008, the number increased to 349,116. As a side note, in the team's original application to leave Columbia for Greenville, the owners predicted attendance of 250,000 each year—a number that minor-league baseball questioned as very high. It went to 335,139 in 2009 as the stadium picked up a naming rights sponsor in Fluor, an international construction powerhouse that traced part of its heritage back to the old Daniel Corporation. In 2012, the team created a major campaign to get to 350,000 visitors. In addition, the Drive has outdrawn the Mississippi Braves every season by almost 100,000 people per year, despite playing in a lower classification.

Fluor Field has become a drawing point for the community, as it is more than just Drive games. Road races use it as a start and end point. College games, including the beloved Clemson versus USC rivalry, are held there

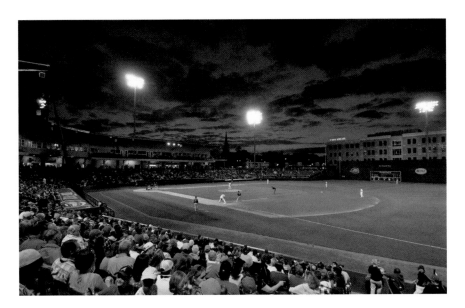

A view from Fluor Field's first base line. The ballpark won over Greenville and its visitors with its charm. *Courtesy of the Greenville Drive.*

in the spring. Roger Clemens and Jim Rice have graced the stadium. Fluor Field was named Ballpark of the Year for 2006 by Ballparks.com. There have been actual on-the-field highlights, which many people thought couldn't happen at the Class-A level. The Drive made the playoffs in 2009 and 2010—both times making the championship series. In 2011, the team missed the playoffs by a few percentage points. Fluor Field also saw the last hurrah of John Smoltz. The right-hander was a Braves stalwart for almost two decades, and he loved pitching in Greenville during rehab assignments. His connection with Greenville was considered lost when the city became a Red Sox affiliate. However, he tried to make a comeback in 2009 and signed with Boston. His first game back pitching came before a packed Fluor Field on a Sunday in late May.

"We always felt that baseball was a downtown business and that Greenville had one of the best downtowns in America," Brown said.

White said that the stadium has exceeded all expectations. It has become a destination downtown—something that the LDR report often called for—as well as a catalyst for redevelopment in the area.

And amazingly, traffic never became an issue.

Chapter 10
Lessons Learned

In the fall of 2012, a developer came before city council to get a zoning change for a piece of property on Ladson Street. The developer wanted to build an office on the corner of this otherwise residential street that backs up to Mills Avenue. It was a nice-looking building, and the development was needed. Council denied the request. Why? The council has learned from past mistakes. Mayor White reminded everyone in council chambers that night that one of the biggest mistakes the city ever made was allowing the Pettigru District to go from residential to commercial in the 1970s. Not only did it kill off a large neighborhood that would have attracted residents during the downtown boom of the past thirty years, but it also prevented the creation of a larger demand for office space in the Central Business District. White doesn't blame city officials for the decision—it was a good idea at the time to help save a dying neighborhood. But the city can't make the mistake of not looking into the future anymore.

The national emphasis and press that downtown has received in the 2000s is well earned, but it puts the rest of Greenville under a microscope to some extent. Council now looks at how to replicate that success in other parts of the city. Ladson is one example. Letting commercial sites in without a plan now could kill a neighborhood ten years down the road.

It is a balancing act that comes with success.

Intercity visits from the 2000s show the change in direction of Greenville. These Chamber of Commerce–sponsored and driven events were ways for Greenville leaders to learn the best practices from other cities. In the

1990s, it was trips to places like Baltimore and Chattanooga to learn about riverfront development, which was key to Greenville's future growth. It has evolved over time to include trips to Austin for culture, Ireland for entrepreneurs and Europe for tourism. And on the flip side, communities from across the country come to Greenville to glean new ideas with degrees of success. Leaders from Topeka, Savannah, Knoxville, Greensboro, Boise, Winston-Salem, High Point—pretty much every city Greenville's size and scores of others—have come to Greenville to study, learn and take back. It's not unusual to see White with his hands on a microphone standing in the middle of a trolley cruising Main Street, giving an impromptu lesson on urban design to out-of-town dignitaries. White has letters from leaders across the country stuffed into boxes and files in city hall. The message is usually the same: "Thanks for showing us downtown Greenville and the difference it can make for a community."

A 2013 piece in the *Greensboro News and Record* by Allen Johnson stated, "In 2005, I was among two busloads of Greensboro folks who visited Greenville, S.C., of all places, in search of a better downtown. Until then, Greenville, for me, had been a faceless blur of signs and exits on the way to Atlanta. And the place the late, great N.C. State basketball coach Jim Valvano once joked he'd mistakenly flown to in the quest for Greenville, North Carolina. 'The stewardess sees me and she asks if there's a Wolfpack Club in Greenville,' Valvano said. 'I tell her that there is and she looks at me kind of funny.'" Greenville is neither a wrong turn nor a punch line anymore. While it's still aware of the potential for mistaken identities, it's a hot enough spot these days that it can even laugh at itself. The catch phrase for its latest marketing campaign: "Yeah, that Greenville."

Chris Stone, president of the Greenville CVB and the organization behind "That Greenville," said the success of downtown is seen by the people who live here. A place can't be authentically good to visit unless the people who live there actually enjoy it. Downtown has that. Stone called it an "enormous stamp of approval."

"The dining piece is fully taken care of. Arts and entertainment are definitely in good shape. And we see people walking around all the time with cameras, and we don't think anything of it. We know what they are taking pictures of," he said.

As this book was being written, numerous projects were being announced to add to the Greenville skyline. On the day Aughtry sat in his fifth-floor office at Main@Broad to recall stories of downtown in the early 1960s, he told the media he was working on a deal to build an Embassy Suites at

Office space, restaurants, retail and residential—RiverPlace is a near-perfect example of Greenville's commitment to mixed use. *Courtesy of John Boyanoski archives.*

RiverPlace. It came a few days after the JHM Hotels announced its plans for a hotel at the corner of Spring and Washington Streets. There are at least a half dozen apartment complexes in the works that are being geared to make downtown living more affordable. A new restaurant seems to be announced every other week, or some entrepreneur is setting up a new business in the downtown core.

And then there are projects such as an expanded zoo, a new children's theater and a new West Greenville park, among others, on the books in Greenville that will affect downtown in the next two generations. Main Street is seeing rapid changes with developments such as One becoming part of the horizon. While many of the small shops are redone, there are numerous large tracts such as the Greenville News Building that are expected to be redeveloped.

A typical day in Greenville is something truly to behold. It is a small southern downtown that is alive twenty-four hours a day, 7 days a week, 365 days a year. Pick a point at any time of the day, and something is going on. At 4:00 a.m., it is city cleaning crews sweeping the sidewalks, emptying trash cans, blowing leaves or driving street sweepers. At 5:00 a.m., it is delivery trucks dropping off food and beverages to those one-hundred-plus

restaurants. At 6:00 a.m., it is the runners and joggers flitting out in packs and singles. At 7:00 a.m. and 8:00 a.m., it is the morning business crowd meeting to deal at Coffee Underground, Joel's Java, Mary Beth's or some other early morning port of call. From 8:00 a.m. to 10:00 a.m., it is the morning commute for workers—Greenville's daytime population more than triples in large part due to the downtown workforce. At 10:00 a.m., it's *Your Carolina*, a morning talk show being filmed live at Michelin on Main. From 11:00 a.m. to about 2:00 p.m., it's lunchtime. Just try to find street parking during these three hours. From about 2:00 p.m. to about 5:00 p.m. is when shoppers and errand runners descend downtown. After 5:00 p.m., there is no mad exodus of cars piling up to leave. Instead, it is more cars coming for dinner and happy hour. If it is during the summer or spring, people are coming for a mini-festival of some kind, whether it is live music on the street, outdoor movies or art shows. As night rolls in, people pack bars and restaurants in cliques and parties that last well past midnight. And that is just a weekday. It doesn't even consider the people who flock to the Peace Center on Friday night or walk Falls Park on Saturday or take a trolley to a Drive game on Sunday afternoon.

"There is something to downtown Greenville that reflects the people here. Downtown is a result of our entrepreneurial spirit, but it is also a catalyst. You are visually stimulated every moment. Every minute is valuable. It's not 'Let's go eat at a specific place or a do a specific thing,' but it's 'Let's go eat downtown,'" said Bob Hughes.

It is a far cry from the downtown of the 1970s, when the streets were bare of people. It is a long way from the 1980s, when the first glimpses of success were seen, but in spurts. It is miles away from the late 1990s, when young professionals populated bars at night but Greenville was ghostly quiet during the weekend daylight hours. It is even different from a decade ago, when Greenville already had found its successes and was being hailed as the next great city. It also leads one to ponder what will be next.

Whitworth said that for all of the accolades, she thinks downtown is just hitting its stride. Sitting in her office on the ninth floor of city hall, which is split halfway between economic development and the city attorney's offices, she quickly rattled off about a dozen projects and areas that can still be developed in the next twenty years: the old Memorial Auditorium site, the large vacant parking lot at the corner of Main and Broad, the Greenville News Building, numerous dirt lots in the West End, the rest of RiverPlace and more in-fill development. And that was just Main Street. She thinks the next wave will be development out to the Kroc Center. A lot of people see

the Kroc Center as an amazing asset but something that has to be driven to. She points out that ten years ago, people felt that way about the West End. Change will happen.

"There is just plenty of opportunity for new development and in-fill development," she said.

Jay Spivey said, "In the mid-1990s, people were questioning redeveloping the West End and that it would hurt what was working farther up Main Street. It was very shortsighted and not long term. Of course, when the West End sparked in the mid-2000s, people worried about the north end of Main Street. Now you have One and the Hyatt renovations that are bringing new life that way. It's come full circle." Jim Bourey said numerous things have helped set Greenville apart when it comes to revitalization: the public-private partnerships, the pedestrian scale of Main Street, a walkable core and planning. "Greenville made a plan and stuck with it," Bourey said. "That makes a big difference." Bourey also credits sustained leadership. Greenville essentially has had three mayors since 1973—Heller, Workman and White (save for a four-year point between Heller's election and his stepping down when three different men held the post). In addition, there have been no wholesale changes to city council, and at one point in the early 2000s, no council member even faced a political challenge. Aughtry echoed those statements: "Greenville has been very fortunate. It has been the beneficiary of some great public talent that worked very well with the private sector." Warren Mowry, an attorney and former prosecutor, said "twenty-five years ago I was prosecuting shootings and stabbings on Main Street on a weekly basis. There was only a small oasis that was open to law-abiding citizens after dark. Now, you can walk from Stone Avenue to Church Street without hesitation."

Shaw notes that Greenville's success isn't any one person's or group's success. It has been a community-wide effort that has spanned generations. A lot of it can be traced back to decisions made in the early 1970s. "A lot of things happen out of crisis. I think we found ourselves in a crisis situation because the stores were closing up and down Main Street. We were not unusual because that was like a lot of towns our size. What made us unusual was we had some very visionary people who were willing to take the heat when it got pretty hot and exert leadership skills to get something done," she said.

But in the long run, it comes down to a lot of people working together. "You had a lot of groups working together for the benefit of Greenville. It wasn't isolated efforts. Everyone was right in there. We've had a comprehensive group of people," she said.

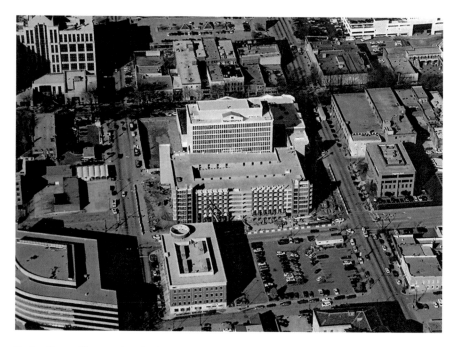

Spring Street Garage played a key part in changing the way Greenville looked at development. For the first time, mixed use figured into construction of a large parking structure. *Courtesy of the City of Greenville.*

It is an effort that has reaped a lot of praise for Greenville, Main Street and downtown that shows the diversity of what Greenville has done. *fDi* magazine called it the top American City of the Future in 2011–12; *Men's Journal* named it one of the nineteen coolest towns in American in 2001; Relocate-America.com hailed it as the sixth-best city to retire to in 2011; *Forbes* put it in the top fifteen cities for young professionals in 2011; *Inc.* magazine called it the nineteenth best city for doing business in 2008; and it won the Great American Main Street Award in 2003 and 2009.

While Greenville's success is warranted and acclaimed, there are issues. Many sites have found new life, while other pieces of property remain a mystery, including the former Greenville Memorial Auditorium site. The Memorial Auditorium, aka the Big Brown Box, was Greenville's entertainment complex for decades and may be most known as the last stop for the classic Lynyrd Skynrd lineup before the band's plane crashed in a Mississippi swamp. Dozens of projects and proposals have been pitched for the land, including a ten- to fifteen-story office complex, a condo project, a series of three buildings on the site, a new federal building and several more projects thrown in for good

measure. Located at the intersection of East North and Church Streets, it has become somewhat of a thorn in the side of the city. Seemingly located at the gateway to downtown and often referred to as the "Gateway site," it remains a vacant lot almost twenty years after the auditorium was demolished. The mid-2000s saw a series of announcements for a downtown tower that, for most part, never broke ground, save the One building, which started in 2012. Youth violence rose in the late 2000s to the point that a curfew was put in place for downtown where anyone under age eighteen is restricted past a certain hour without a legal guardian. Parking is a constant complaint. While the city has about a dozen parking garages downtown, people will still try to park illegally as much as possible and then complain about tickets and booting.

Hughes said Greenville's success is due to its people and the fact that it learns from its mistakes: "Greenville has had a lot of victories, but we have a lot of failures. A lot of them. But we didn't dwell. We learned from them. You need failures in order to learn."

What will Greenville's downtown look like in the next decade and the decade after that? That is the challenge and the question. In 2008, the planning commission created a twenty-year master plan that calls for downtown to continue to expand off Main Street and push on to the concrete collars of Academy and Church. That same year, Sasaki and Associates said Greenville needed to focus on "five corners" in order to keep the momentum:

- Heritage Green: Making it an easier walk to the museum area from Main Street.
- Gateway: Making sure a signature building is there.
- County Square: Building a high-rise structure or something that reflects on downtown.
- Broad and river area: Making it a premier spot for tourism.
- West End: Converting warehouses into "cool space."

The idea remains simple: spread away from Main Street while keeping that very important corridor strong. A challenge to downtown will be the scale. Main Street is essentially a pedestrian-friendly street with a series of two-and three-story buildings up and down. It creates a somewhat cozy feel, but as the demand for real estate rises along with prices, buildings will have to get taller. Greenville has prided itself on not being a mass of glass-and-steel towers like its I-85 compradres in Atlanta and Charlotte, but some wonder how long that can last. For decades, everything went unchecked, but the city has had downtown design guidelines in place since 2000 that are designed, not to create conformity, but to prevent misuse. City officials have started to

discuss revamping the design standards to allow more height, but it is tough to say how long that process will last and where it will head.

Growth is one thing, but redeveloping is another. Projects such as the Hyatt renovation, the Peace Center upgrades and the potential for the Bank of America to be redone are examples of mistakes Greenville has learned from. It is good to reinvest in what a city already has, Whitworth said.

"When you think of all of the other opportunities, it's not over yet. The great part of Greenville is that we are just really hitting our stride. I think it is just going to get better. The difference is we are maturing and spreading. That is not necessarily a bad thing. We have done it so incrementally that it doesn't really feel like a rapid change. The magic of Greenville is really what we do is common sense," she said.

As for the Hyatt, almost thirty years after its initial grand opening in a snowstorm, it underwent a major overhaul for most of 2012 under new ownership, JHM Hotels, Inc. The highlight was something called NOMA Square—a public space along Main Street. It was a reinvisioning of the former public space that had been a hallmark of downtown for years. The new square has a European feel and more tenants that make it feel more like the rest of downtown as opposed to some blasé entranceway of the hotel. The president of JHM, D.J. Rama, told the *GSA Business Journal* that it was more than just a renovation project. He felt his team was keeping up a vision started more than thirty years ago by Heller.

"We felt that we're his trustees of the hotel."

Mayor Knox White concludes:

> *The secret to Greenville's success wasn't really a secret. It was planning. It was implementing. It was bringing people together who believed. It was listening to those who didn't believe. It was changing people's minds. It was about creating a vision and making it happen. That is the big difference. It wasn't one thing that happened; it was all of those things and more. And when one thing happened, we pushed for something more. That is the key to the future. We can't rest on what we have done and expect it to keep being prosperous. We can't be complacent. We have to be looking and thinking about what will come next. That is the answer. The lesson of all of this is not to lose sight of the big picture. That is the most important thing. A lot of cities do that, though. They get so bogged down in the minutiae of zoning requests or barking dogs that they don't think about what will make their city better in the long run. The challenge is to keep trying and promoting new ideas. Once something works, other cities will steal it. We've seen it locally. You just can't stay still. We have to keep doing things that will be a success.*

Sources

The following media were researched and sourced when writing this book:

Atlanta Magazine
Columbia State
Esquire
Garden & Gun
Greensboro News & Record
Greenville Business Magazine
Greenville Journal
Greenville News
Greenville Piedmont
GSA Business Journal
Huntsville Times
New Yorker
New York Times
NPR
Our State
PBS Public Radio
Southern Living
Spirit

Index

About the Authors

John Boyanoski spent a decade covering the city of Greenville (and other beats) for the *Greenville News* and *Greenville Journal* before opening his own public relations firm in 2012. A winner of numerous journalism awards, he is the author of three other books and is active in the community, sitting on several boards. He is a native of Scranton, Pennsylvania, and a graduate of Syracuse University.

Knox White has served as mayor of Greenville since December 1995. As mayor, he has the goal of making the city of Greenville "the most beautiful and livable city in America." He has emphasized neighborhood revitalization, economic development and transformational projects for downtown. A native of Greenville and a graduate of Christ Church Episcopal School, Greenville High School, Wake Forest University and the University of South Carolina School of Law, Knox White is a partner in the law firm of Haynsworth, Sinkler & Boyd, where he heads the firm's immigration and customs practices. He is married to Marsha P. White, and they have two children.

Visit us at
www.historypress.net
..
This title is also available as an e-book